WITHIN THESE SHORES

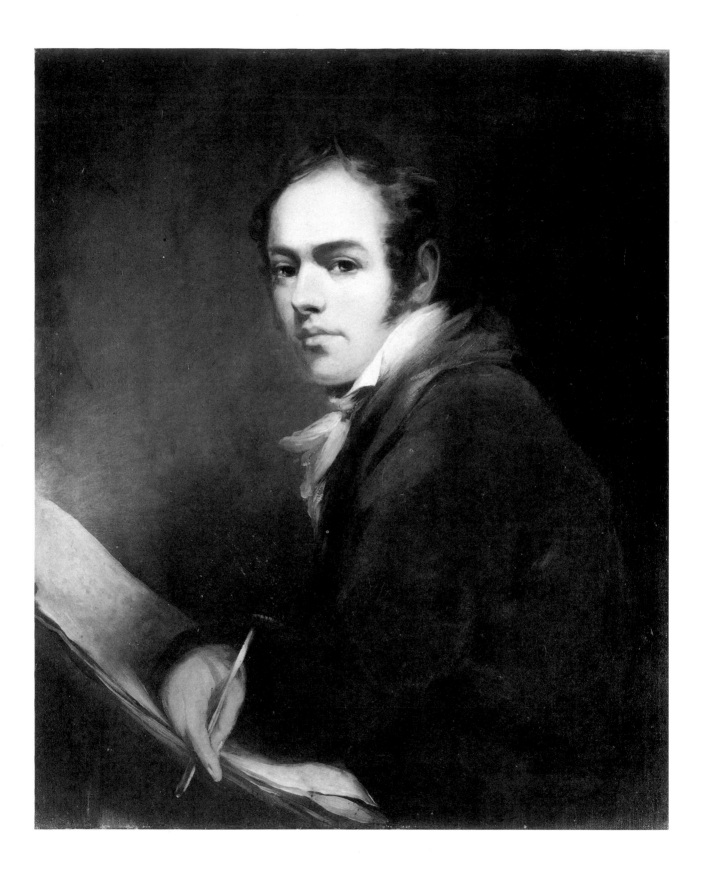

Within these Shores

A Selection of Works from the Chantrey Bequest

1883–1985

THE TATE GALLERY

in association with

SHEFFIELD CITY ART GALLERIES

Contents

Acknowledgements

The editors and compilers wish to thank the President and Council and the Secretary of the Royal Academy for permission to consult the Account Books and the Minute Books of the Trustees of the Chantrey Bequest. Mary Ann Stevens, the Academy Librarian, and her staff generously made available the resources of the library where Helen Valentine patiently and cheerfully dealt with innumerable requests for help.

Foreword

As a sculptor Francis Chantrey (1781–1841) hated allegory, but the figures of Fame and Fortune nevertheless hovered closely over him. As a national figure his artistic career knitted with the fabric of growing confidence in the power of the nation in its early Victorian heyday. He was a self-made man, who none-theless never forgot his origins. Born in Norton, a village then some mile or two outside the burgeoning big town of Sheffield, he was buried there at his wish on his death in November 1841. Chantrey was the son of a small tenant farmer and carpenter, who soon 'left off chopping sticks and took to chipping stones'. The links with Sheffield remained, those of family, apprenticeship, encouragement, early patronage – 'portraits in crayon and miniatures' and a first commission in 1805, a monument to a Sheffield vicar. As a result of these affirmed links, Sheffield itself never relegated its affection for one of its sons. In 1951, Chantrey along with that other Victorian artist and Sheffielder, Alfred Stevens, seemed appropriate figures to focus on in a Festival of Britain exhibition at the Graves Art Gallery in Sheffield. More recently and in more sober art historical vein, the City's Mappin Art Gallery collaborated with the National Portrait Gallery in the impressive 1981 bi-centenary exhibition. This constituted a timely reappraisal of Chantrey's status as a 'sculptor of the great' – not that Sheffield had ever been prey itself to seeing any fluctuation of esteem for Chantrey. Because of this sustained interest in Chantrey, we find also a perennial interest in the Chantrey Bequest collection.

Chantrey's Bequest must rank among the most imaginative and generous for the nation. Its origins, its precise terms and what it has meant for British art are dealt with in the essay that follows this Foreword. Chantrey's desire to establish 'a PUBLIC NATIONAL COLLECTION OF BRITISH FINE ART IN PAINTING AND SCULPTURE executed within the shores of Great Britain' we can see as both farsighted and shortsighted. Farsighted, because this is among the first intimations in the wake of the founding of a National Gallery and its establishment in a proper home in Trafalgar Square in 1838, that the artistic life of the country warranted also a commitment to living, contemporary work and not just to the art of the past. Shortsighted, because of his näive optimism and 'confident expectation that whenever the collection shall become or be considered of sufficient importance, the government of the country will provide a suitable and proper building or accommodation for their preservation and exhibition as the property of the nation'. If we add hindsight, then we must conclude that Chantrey should have left a separate building endowment fund!

A selection from the Chantrey Bequest was last presented in Sheffield in 1958 when some 82 works from a collection that then stood at 477 in total were

displayed. A measure of the affection for the collection can be adduced from the popular response to the Royal Academy's more recent show *Some Chantrey Favourites*, though perhaps the exhibition's title pre-empted critical demurring. A selection now for an extended exhibition in Sheffield in 1989 allows us to range across the history of the collection and its times, realise its continuing work and also perhaps reflect on the persistent revisionism which perhaps provides the only real critical and historical tool with which we can approach the last century of art within these often insular cultural shores.

The City Art Galleries are extremely grateful to the Trustees of the Tate Gallery and the Trustees of the Chantrey Bequest for the sympathetic consideration and approval given to this exhibition request from Sheffield. The project would have foundered but for the support of Nicholas Serota as Director of the Tate and his predecessor Sir Alan Bowness. We are indebted to all the curatorial, technical and administrative staff at the Tate Gallery who have helped make this project possible. The City Art Galleries, in common with other regional art galleries, are fortunate to benefit from numerous long-term loans from the collections of the Tate Gallery. The mounting of this exhibition presented a particularly onerous and concentrated burden of work in the administering and processing of loans, but one whose success augurs well for possible future collaborations. The City is the beneficiary but the Tate too, in this regional undertaking, adds a further gloss to its national rôle. This co-operation is particularly appropriate as the exhibition forms a contribution to the Museums Year 1989 programme.

The exhibition has been jointly curated and catalogued by Dr Judith Collins, Rosemary Harris, Ann Jones, and David Fraser Jenkins, Curators in the Modern Collection, and Robin Hamlyn, Curator in the Historic British Collection at the Tate; and Anne Goodchild, Assistant Keeper for the City Art Galleries in Sheffield. They have brought their combined and substantial experience and appreciation of British Art and the era to bear on this exhibition for our delight and interest. The mounting of the exhibition at the Graves Art Gallery in Sheffield has been facilitated with the generous support of ICL (UK) Ltd. The City Art Galleries gratefully acknowledge all these collaborative efforts. Our hope is that the exhibition and this accompanying book will be a source of pleasure and interest to our public within, and indeed beyond, these shores.

David Alston *Deputy Director of Arts, Sheffield*
April 1989

Sir Francis Chantrey: His Bequest in Context

Patrons, Painters, and the Art-Market in the early Nineteenth Century

'. . . the indecorum and impolicy of hanging the works of living artists in the same room with the productions of the Old Masters' *Athenaeum*, 1830.

The image of the 'romantic' artist as an impetuous, impecunious, passionate 'outsider', buffetted by fate, railing against men (and women) and dedicated to his art to the exclusion of more-or-less everything else, is one that is deeply embedded in peoples' minds. However, it is quite easy to demonstrate the falseness of this notion and to do so, it is not even necessary to make a detailed study of the lives and output of some of the greatest figures of romantic art. The point is proved quite simply by contemplating the origins and substance of two bequests, bearing the names of two of Britain's greatest romantic artists, which are to be found in the Tate Gallery.

These two artists were not only rational and sociable men – who placed great store by belonging to a club, the Royal Academy – but also efficient men of business. In the course of their long careers they amassed substantial fortunes. They possessed a profound concern for the welfare of fellow artists and they had a sincere pre-occupation with the state of the fine arts in their country: not only for the art of their own time but also for that of the future. Surprisingly perhaps, for modern sensibilities at least, this was motivated by nothing less than genuine patriotism. The artists in question are, of course, the painter J.M.W. Turner (1775–1851) and (rather less well known) the sculptor Sir Francis Chantrey (1781–1841).

Their bequests are very different. Turner's, as it stands in the Tate, represents just one facet of the wide-ranging benefits which he hoped his legacy of pictures and his fortune would bring to British art. For various reasons these benefits live on now only through his art but nonetheless even this fact is sufficient to illustrate our argument. By contrast, the Chantrey Bequest is something which is very much alive in the truest sense of the word. At the present time the works purchased under the terms of the sculptor's will and in the Tate consist of oil paintings, watercolours and sculptures produced by more than 350 artists who have worked in this country. These works (and there are 521 at present) have all been purchased since 1877 which is when his will came into force. They cover a period from 1852 up to the present day

and the collection is still being added to. The Turner Collection is displayed in its own rooms at the Tate and enjoys international renown as a unique collection of pictures by England's greatest artist; the Chantrey purchases, however, are by no means all on display and when they are they are found scattered throughout the Historic and Modern Collections of the Tate. Not only is the Bequest barely known inside or outside Britain but the idea of it as one of the surviving fragments of an elaborate system of art patronage which artists themselves created during the nineteenth century passes more-or-less completely unrecognized.

To understand how and why the Chantrey Collection or, for that matter, the Turner Collection, came into existence it is necessary to look back to the early years of the nineteenth century – the period just around 1802 when the twenty-one year old Chantrey arrived from Sheffield to commence his career as a sculptor in London. At this time, the modern British School of art was still relatively young. Those who were by general consent regarded as its founding fathers, William Hogarth (1697–1764), Richard Wilson (1714–1782), Thomas Gainsborough (1727–1788) and above all the first President of the Royal Academy, Sir Joshua Reynolds (1723–1702) had all been active within living memory. It was not until the end of the second decade of the century, in 1818, that the Royal Academy, containing the country's first proper art school and mounting the most important exhibition for contemporary artists, celebrated its fiftieth birthday. And yet despite its youthfulness the British School of painting made remarkable strides over the period. By 1820, London supported a community of nearly six hundred artists: Joshua Reynolds's hope, expressed in 1769, that 'the present age may vie in Arts with that of Leo the Tenth' (who was the Pope who patronized, Raphael, Leonardo and Michelangelo) seemed at last about to be realized as a host of brilliant talents emerged to build upon the achievements of an earlier generation of artists. Those singled out for public acclaim at the time included Turner, David Wilkie (1785–1841), Thomas Lawrence (1769–1830), Edwin Landseer (1803–1873), and Chantrey himself; hardly lionized but just as important, was John Constable (1776–1837). If one were to single out the most exciting and interesting period of British art it would probably be the first twenty to thirty years of the nineteenth century.

The excitement of those times that is still conveyed to us through its art, artists' letters and journals and newspaper reviews undoubtedly owed quite a lot to a chauvinism among a relatively close-knit circle of artists and critics that was not unrelated to British successes on the battlefields of Europe during the Napoleonic wars. The Prince Regent in a speech to the Royal Academicians in 1811, reported in *The Examiner* of 5 May 1811, caught the mood of the times when he said:

that great as this country now appeared in the eyes of Europe by her exertions in arms, by her constitution, her liberties and her laws, the time was fast approaching, if it has not arrived, when her superiority in the Arts would be equally acknowledged.

Certainly it was never in doubt, as far as English artists were concerned, that the merits of technical virtuosity, or painterliness, colouristic skills and, through the life class, a close study of nature which were instilled by the Royal Academy's sometimes lax teaching system, were far superior to the cold, hard, formal values which characterized the products of the more rigid teaching methods of the French School.

The understandable air of superiority which members of the British School bore when drawing comparisons with their nearest continental neighbour was not wholly the product of insular self-congratulation. There was sufficient, if intermittent, recognition from outside the country to make her artists feel that their credentials in all areas of endeavour – history painting, landscape, portraits, and scenes from familiar life or *genre* – were well established in a truly European context. Benjamin West's picture of 'Death on a Pale Horse' (now in the Detroit Institute of Arts) was well received at the Paris Salon of 1802. Following the victory of Waterloo in 1815 and the opening up of the Continent after the war years, Thomas Lawrence set off in 1818 on a trip around the capitals of Europe with a Royal commission to paint portraits of heads of state; during this time he confirmed his position as one of the foremost portraitists of the age. In 1819, Wilkie was commissioned by the King of Bavaria to paint a genre subject 'The Reading of the Will' (now in the Neue Pinakothek, Munich). In 1824 Constable's 'The Haywain' (now in the National Gallery) was one of two landscapes by the artist which aroused public curiosity and admiration when exhibited at the Paris Salon in 1824. Finally, we have the small exhibition of his own paintings which Turner mounted in Rome at the end of 1828. Here in the Eternal City, the home of that art to which Reynolds so wished his followers to aspire, the bafflement and wonder among native and British visitors alike which Turner's works provoked now seems to symbolize the real supremacy of British art over its contemporary rivals: vigorously individualistic, free from studied conventions and revelling in mastery of painterly technique.

Whilst the way in which the achievements of individuals gave lustre to the British School as a whole was a highly satisfactory situation, ultimately the health and survival of British art was dependent less upon mere praise than upon active patronage right across the board. Here, even leaving aside the ritual complaints of artists themselves about lack of patronage, it is quite clear that their growing hopes for success were not being matched by a

corresponding increase in the size of the picture buying public. So, by the very end of the 1820s attendances at the Royal Academy annual Summer exhibition were only up by about twenty thousand on what they had been at the beginning of the century. A more telling figure, and the only one of its kind from the period, is the one that shows that on average only about 20% of the pictures exhibited each year at the British Institution galleries during the 1820s were ever sold off the walls. In fact, the percentage of works sold fell off slightly over this period, despite there being an increase in attendance figures; it was a trend attributable, no doubt, to the emergence of other public exhibitions, but it is nonetheless, some indication of the fact that the market was not responding to the widely canvassed view that the cultivation of the arts was an essential attribute of a rich and successful society which lay, as London did, at the heart of an expanding empire.

There were, it is true, a few important individual patrons collecting British art – the most important of whom will be referred to shortly. However, one of the ironies of the situation in which British artists found themselves during the early 1800s was that the continental wars in which their country was having such marked success and which helped invigorate the concept of a 'great' British school, also created an influx of Old Masters onto the art market. These were flushed out of European galleries by wartime conditions. Generally, those people with money who wanted to patronize the arts preferred to acquire paintings by Old Masters of proven reputation rather than gamble on acquiring works by living artists whose future reputation (and thus the resale value of their work) was a completely unknown quantity. In such circumstances, the usual recourse of artists and the associations which represent them is to appeal to the government of the day for help: the early 1800s were no exception to this rule. The Royal Academy made various unsuccessful attempts to encourage government patronage of the arts; unfortunately, by owing allegiance to the Monarch, and at this time particularly its founding patron, George III, and jealously guarding its independance to the extent of being entirely self-financed, out of its exhibition takings, it could not have any effective rôle to play in the forming of official taste. It encouraged merit among its students and funded foreign travel for them through a system of competitions and awards; it even possessed the makings of a national gallery of British art in its own collection of Diploma works – works which Associates of the Academy (A.R.A.) were required to deposit when they were made full Academicians (R.A.). Likewise, the British Institution founded in 1805 by an association of noblemen and gentlemen and funded by their subscriptions, attempted to promote painting and sculpture through commissions and prizes – the commissions being intended to form the basis of a national gallery of British art. But the great apparatus of state

and Académie des Beaux-Arts which existed in France, combining to support the Prix-de-Rome for history and landscape painting which conferred money as well as national honour upon its recipients, was unknown to Britain. So also was any equivalent to the Museé Royal du Luxembourg wherein was housed the National Collection of pictures by living artists which the French Government had purchased.

Artists as Patrons

'England expects every Man to do his duty . . .'

<div align="right">J.M.W. TURNER quoting HORATIO NELSON</div>

This perhaps gives some idea of the public face of arts patronage during the early years of the nineteenth century; how it was an issue which, inevitably, became inextricably bound up with questions of national pride, political expediency and financial rectitude. What also has to be considered is the more private form of patronage which, in a characteristically British way, gradually arose to fill the vacuum created by the state's absence from the field. It is in this that we can find the real roots of the present day Chantrey Collection.

A glance through the catalogues for the sales of the contents of deceased artists' studios which occurred in London during the late eighteenth century and the first half of the nineteenth century reveals two interesting facts. Firstly, that it was quite common for painters to buy work by dead British artists for whom they had a particular admiration or whom they felt had made a significant contribution to the development of the national school. Turner, to cite a notable example, bought at the studio sale of Reynolds, acquired drawings by Thomas Girtin, P.J. de Loutherbourg, and M.A. Rooker, and bought Hogarth's palette – which he later offered to the Royal Academy. Secondly, the practise of giving, buying or exchanging their own works among artists was quite widespread. To some extent, then, the British School was always engaged in a modest exercise in self-promotion.

At just what moment such an essentially private impulse to collect works of art by his peers assumed a self-consciously public rôle in the mind of the nineteenth century artist is a matter of great interest. It was at that moment that the acquisitive impulse, whether fired by sheer admiration for another artist's work, or wider knowledge of public indifference to an artist's merits or the desire to preserve exemplars for younger colleagues, but always bound by simple domestic considerations such as lack of display space, became transposed into a desire to actually publicly celebrate British art and artists. It is this which is, after all, the continuing function of the Chantrey Collection,

however blurred its original grand design may have become through unfamiliarity with its origins or through the piecemeal way in which it has grown.

The first vision of such a monumental concept and the will to realize it could only be products of a particular cast of mind. Significantly, it was an architect, John Soane (1753–1837), well versed in the design rhetoric of public buildings and mauseolea, above all familiar with the very notion of monumental built form, who pointed the way ahead for Chantrey as well as Turner. And if any one event signalled the way in which successful creative artists henceforward committed themselves to promoting British art it must be that time in February 1802 when Soane bought, at auction, William Hogarth's set of eight pictures 'The Rake's Progress' of 1733.

Soane's greatest architectural project at this time, triumphantly completed by 1823, was the remodelling of the Bank of England, but apart from being a designer he was also a notable collector of art and antiquities. His acquisition of the Hogarths seems, however, with its nationalistic as well as didactic overtones, to have a rather special significance in that it bears all the signs of Soane having a greatly enlarged view of the purpose of his collection. They were the most important pictures so far bought by him and they were also representative of Hogarth's treatment of 'modern moral subjects'; in short, they were a highly distinctive contribution to British art made by the painter who was, as has already been mentioned, one of the founders of the modern school. The pictures can still be seen in the Soane Museum in London and even today their moral tale about the perils and rewards of profligacy is capable of exerting a considerable hold over the viewer. As an illustration of the power of art – with its injunction to avoid excess and thus embrace industry – it was an object lesson to any aspiring artist; moreover, this was a power which had been successfully harnessed in a unique way by an entirely home-grown talent.

Thirty years later, Soane had printed privately a *Description* of the contents of his own house, By this date his house was, properly speaking, a semi-public museum – freely accessible to colleagues and students. That the twin thrust of the lesson set by Hogarth was never far from his mind in its creation is underlined by his allusion to the artist's moral subjects when stating that the *Description* (which describes all the paintings, drawings, sculptures, books, manuscripts and models he had brought together) exemplified 'the almost certain successful results of industry and perseverance'. In the same book Soane rightly claimed that one of the purposes behind his museum was his 'desire . . . to promote, to the utmost of his power, the interests of British Artists . . .'. This he had indeed done, in his own words, 'by giving commissions to some of the living and by collecting together as many of the works of our highly talented deceased countrymen as I had the means to purchase'.

Aptly, the *Description* contains a separate index of the names of the fifty-three British painters and sculptors who were represented in the collection.

By 1832 although there were a few private collections which came near Soane's in the range of British art which they contained, most significantly none of them possessed the 'public' rôle which Soane allocated to his collection. This rôle was formalised in 1833 when a private Act of Parliament, initiated by Soane, established the house as a study collection, open at set times and by appointment, for students and amateurs of the arts. Soane is by any account a figure central to our understanding of the course which the patronage of British Art took during the 19th century. This is not so much because of the overall quality of the collection he formed, which is uneven, but more for the way in which he showed how a successful artist, in the absence of any sustained committment to the arts from the State, could nonetheless pursue a great, national, design: British artists, when receiving a commission from Soane, worked in the knowledge that their pictures would find a place in a gallery which had the status of a national collection. Needless to say, Soane was a Royal Academician: some twenty years their senior he was a close colleague of both Chantrey and Turner, both men were represented in his collection, in Chantrey's case notably by a portrait bust of Soane which the sculptor presented to the architect in 1830 'as a token of respect'. The bequests of both men were undoubtedly coloured by Soane's activities.

It is right that Soane should be singled out as the guiding light in these affairs but there is one other figure who ought to be mentioned in the same context. At first sight the connection might seem tenuous: he was Italian and so, apparently, far removed from the immediate concerns of British artists. But Antonio Canova (1757–1822), as the most distinguished sculptor of his day and one of the most prolific, wielded considerable influence throughout Europe. The grace, nobility and poetical fancy of his conceptions and his skills as a worker of marble were unrivalled and earned him the greatest admiration and respect of fellow sculptors. The force of his example extended well beyond his prowess in the field of sculpture. He actively assisted the Royal Academy by procuring casts of ancient statues for the Academy Schools, he spoke up in favour of the Elgin Marbles at a time when the Government was dithering over whether to buy them or not, and his hospitality to English artists and patrons when they were in Rome was always generous.

Among the many visitors he received were Turner and Chantrey when they were in Rome together in November 1819. They met Canova at an interesting moment in his career and even if they were unaware of the contents of the first will which he had made in 1815, wherein he set out some

of his charitable intentions, they could not but have known about what he had already accomplished in this field. As perpetual President of the Academy of St Luke since 1814 he had devoted a large part of his income to helping students of art; when in 1816 he received a substantial pension from the Pope, he also applied this to the cause of encouraging painting and sculpture – his aim being, in the words of a biographer, 'to assist and mature the unbroken energies of youthful talent'. Aged and decrepit artists and their widows and orphans were also supported by Canova. Such similar provisions are all identifiable in both Chantrey's and Turner's wills and it is not unreasonable to assume that an awareness of them in Rome, emanating as they did from the presidingly genius of the artistic community, might have further helped shape their own testamentary intentions. Equally interesting but more for a reading of Turner's will, with its motif of keeping together all his finished work, than for Chantrey's, is one further detail. Only a few months before their meeting, Canova had returned from the town of his birth, Possagno, near Venice, where he had laid the foundation stone of a church which he had designed and for which he was paying. It was intended as an act of piety; it was to be embellished with statues and bas-reliefs of sacred subjects sculpted for the purpose by Canova and it was to be his own last resting place.

How far Canova's example actually influenced Chantrey or Turner is impossible to say. However, during their time in Rome Chantrey specially commissioned his colleague John Jackson to paint a portrait of Canova which he then took home with him. Along with what Soane was already doing, the actions of the Italian sculptor certainly must have reinforced a growing conviction, shared with many others in the profession, that the means of ensuring that the achievements of the British School were given due recognition and, moreover, the means of ensuring its continuing success in the future, lay with artists themselves.

During the years immediately following Turner's and Chantrey's return from Italy one issue in particular appears to have united artists in a common cause. This concerned the fate of the most important private collection of British art then in existence. It was owned by Sir John Leicester (later Lord de Tabley) who had started seriously collecting works by living artists in 1806 though an early indication of his taste can be seen in his acquisition of pictures by Reynolds and Gainsborough during the 1790s. From 1806, when he built a picture gallery in his London home to house his collection, Leicester was active in purchasing direct from artists, from salerooms and exhibitions and by the end of his life the collection consisted of one hundred and fifteen works, nearly all of them by living painters. Leicester's nearest rival in this field was the 3rd Earl of Egremont but his collection was essen-

tially private and housed out of town, at Petworth in Sussex. Not only was Leicester's exclusive devotion to British art unusual at a time when the collecting of Old Masters was considered more judicious and more respectable, but he even went so far as to open his gallery to the public. This he did for the first time in 1818 and then again in subsequent years. The great names from the recent past – Gainsborough, Reynolds, Wilson, were seen alongside the geniuses of the day: A.W. Callcott (1779–1844), William Collins (1788–1847), Henry Fuseli (1741–1825), William Hilton (1786–1839), John Hoppner (1758–1810), George Jones (1786–1869), Edwin Landseer, Thomas Lawrence, P.J. de Loutherbourg (1740–1812), John Martin (1789–1854), James Northcote (1746–1831), John Opie (1761–1807), George Romney (1734–1802), J.M.W. Turner, James Ward (1769–1859), Benjamin West (1738–1820) and others. There was hardly an artist there who is not now found in the present day National Gallery of British Art – the Tate Gallery.

In this display one critic discerned, with ample justification, that 'the vernal season of native genius, which commenced a short time before the Royal Academy, and further bloomed in the British Institution is gradually maturing to a genial summer'. More pointedly, the same critic saw Leicester's act of opening his gallery as 'a satire on Government, which unconscientiously creates sinecures of thousands a year for lazy, worthless courtiers and constitution-killers, but never expends a guinea in furtherance of British genius in painting'. The practical as well as the symbolic value of what he had achieved was not lost on Leicester and in 1823 he proposed to the government that they purchase his pictures as the nucleus of a National Gallery for British Art. Sadly, neither the attraction to the government of being able to, in Leicester's words, 'add lustre' to George IV's reign, or earn the 'thanks and gratitude of the Nation' proved sufficient to persuade the Prime Minister, Lord Liverpool, of the merits of the offer. Other, familiar, factors also conspired against its acceptance: Parliament seemed unlikely to vote any funds in support of the scheme – for the enlargement of the British Museum had become a pressing requirement; and at more-or-less exactly the same moment the Government was about to negotiate the acquisition of an important Old Master collection with a view of establishing *that* as the core of a National Gallery.

What we now know as the National Gallery opened its doors in May 1824 in the former home, in Pall Mall, of John Angerstein whose collection was the subject of the 1823 negotiations. As far as British Art was concerned it came nowhere near meeting the expectations which had been raised by Sir John Leicester's patronage or by his offer to the government. Reynolds and Hogarth were represented alongside Claude, Poussin, Rembrandt, Rubens,

Titian, *et.al.* but David Wilkie with one picture, 'The Village Festival' of 1811 (now in the Tate), was the only living painter amongst them. It was left to one, rather minor, artist, W.F. Witherington (1785–1865) to articulate the most eloquent and elegant riposte to the blow which Lord Liverpool had dealt British art and artists. In a picture entitled 'A Modern Picture Gallery', exhibited at the Royal Academy in 1824 (just when the new National Gallery was opened) but obviously commenced at the time Leicester's offer was rejected, Witherington signalled the continuing belief among artists in the distinctive identity of their school, worthy of comparison with the Old Masters, and staked a further claim for its proper recognition by the State.

The picture (fig. 1) is instructive, and in two details seems to so accurately implicate both Turner and Chantrey in the argument about the ultimate fate of the British School, that it is difficult not to believe that it did not in some way influence them. Before the enlightened gaze of King George IV – who is represented in the bust which Francis Chantrey sculpted in 1822 – Modern British masterpieces, accurately depicted, are arranged, tier upon tier in their splendid gilt frames, in two or three ample rooms. The debt owed by British artists to Lord de Tabley is acknowledged in the presence of a number of pictures from his collection. Amongst these, prominently displayed beside Chantrey's bust, is Turner's 'Sun rising through Vapour; Fishermen Cleaning and Selling Fish' of 1807, acquired by Leicester in 1818, one of eleven Turner's owned by him and the one for which he paid the highest price. For

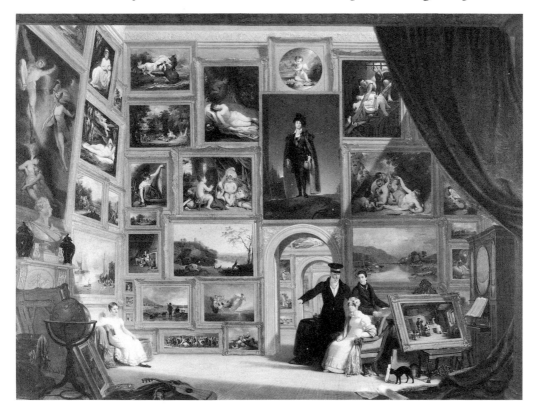

fig.1 W.F. Witherington, 'A Modern Picture Gallery' 1823, oil on canvas 711 × 1219 (28 × 36). Exhibited Royal Academy 1824. National Trust, Wimpole Hall, Cambridgeshire

the moment, Witherington's potent image had to remain an ideal but one which, nonetheless, still seemed worth striving for. The Royal Academy, with its growing diploma collection and its important annual exhibition, in 1825 appointed a committee, amongst whose members were Turner and Chantrey, to examine what it could get out of the new, enlarged National Gallery that was being mooted for a site near Charing Cross (where, ten years later, it was eventually built). In the end, though, it was the fate of the Leicester Collection which seemed to have aroused the most constructive passions. In June 1827 Lord de Tabley, as he now was, died and three weeks later his entire collection was put up for auction. The speed with which this was done, at a time of year when Parliament had risen – and so could not be petitioned to save the collection for the nation – and most potential bidders were on holiday in the country, dismayed the entire artistic community. Many of those who were represented in the collection obviously feared that the low prices which their works seemed bound to sell for in the circumstances would undermine their reputations, but even this had implications for British art as a whole and both Turner and Lawrence in the words of the painter William Collins, did 'everything in their power' to have the sale deferred.

They failed but, in the event, most of the pictures sold for more than de Tabley had originally paid for them. What had seemed a likely disaster thus turned into something of a triumph for it demonstrated that British pictures could, just like the Old Masters, more than hold their value on the open market. In the opinion of one writer, John Pye, 'perhaps [no] event did more to provide employment for British painters for it gave their works the character of desirable property for investment'. Appropriately, a few of the pictures have ended up in the Tate Gallery. Turner was among the artists who bid at the sale and he bought back three of his own pictures, among them the 'Sun rising through Vapour'. It is impossible not to associate the fears and then the hopes aroused by this single happening with two events of the following year. In February 1828, first the Directors of the British Institution, with an eye to a possible home for the half dozen or so British pictures which they had purchased, proposed offering a sum of £4,000 so the National Gallery could be extended; and then Sir John Soane, just one day later, presented them with £500. The offer to help the National Gallery went unheeded by the Government and Soane's gift was ploughed back into the annual premiums awarded to deserving artists. Soane's munificence was, of course, part of a highly individual though well established pattern of patronage, soundly rooted in precedent, but broadening into areas of genuine national concern. Similar concerns on Turner's part were, by this date manifesting themselves – most obviously in his attempt to halt the de Tabley sale and then in his buying back some of his own works from that sale. The

diverse provisions of his first will of 1829 took him a step further, with the bequest of two of his pictures to the National Gallery, the provision of funds to the Royal Academy to support a Professorship of Landscape Painting and the award of a biennial gold medal for landscape, – with the rest of his estate being used to create a 'College or Charity' for 'decayed English artists' whose almshouses would have at their centre a gallery housing Turner's own pictures. So apparently unbroken was the growing web of artists' involvement with patronage becoming that even this last idea must have owed something to Soane's design for Dulwich Picture Gallery, Britain's first public art gallery, opened in 1817, which also incorporated some almshouses. As if to underscore the significance of the rôle played by the de Tabley collection in shaping national aspirations, Turner, in 1831, made a second will in which one of the two pictures originally left by him to the nation in 1829 was replaced by 'Sun rising through Vapour' (which now hangs in the National Gallery).

What remains to be seen is just how far Chantrey's thoughts on the future of British art had matured in the same way. The tentative conclusion must be that by this time he had arrived at more-or-less the same point as had Turner in his first will – despite the fact that his own will was not made until 1840. Like Soane, Turner (as a history painter) and Canova, the conceiving and realizing of a grand design and the process of memorialising within the constraints of the materials to hand, was instinctive and thus central to his art. There are also sufficient indicators of Chantrey's practical view of British art during the 1820s to lead one inevitably to the conclusion that since he was named by Turner as one of his executors in 1829, the broad outlines of its contents must have been discussed by the two men.

We know that Chantrey possessed the same pragmatic dedication to the Royal Academy which both Turner and Soane had. His obituarist in the *Observer* noted that in Chantrey the Academy 'never had a stronger stickler for its principles, its conducts and its laws.' No better illustration can be found of how all three men joined in a common cause at the most practical level than their being the three auditors of the Academy accounts in 1824. Chantrey's own meticulously kept ledgers, still preserved in the Royal Academy and the British Museum, highlight just how such a mundane activity was very much in character. But they reveal much more: how Chantrey's growing professional success, and with it increasing wealth, coincided exactly with that critical period during the 1820s when, as has been seen, the consolidation of the achievements of the British School was so tantalizingly within reach. His annual earnings of about £7,500 in 1820 had virtually doubled by 1828 and in the following year he recorded his highest ever income for a single year – £18,600: it was only this flourishing state of

his private affairs which enabled Chantrey to act in the manner which seemed most appropriate to the times.

Chantrey's close friend, the painter C.R. Leslie (1794–1859), claimed that it was the sculptor's indignation at the continual failure of their colleague William Hilton to sell any of his pictures which inspired him to make his will. Hilton (1786 – 1839) was a history painter working in the so-called 'Grand Style'. Seizing the intellectual grandeur of the ideas which this style embraced, and executing them on an appropriately large scale lay at the heart of Joshua Reynolds's wish to see the arts in his country rival those of Raphael's and Michelangelo's time. A few undeviating purists, Hilton among them, saw it as the only direction in which British art could move if it were in any way to reflect the achievements of a growing empire and ensure its lasting fame. Hilton was, it is true, the victim of State and private apathy and at his death he was mourned by the *Art-Union* in terms of 'the stone which the builders rejected, the same will become the head stone of the corner'. It is also a fact that the first purchase by the Trustees of Chantrey's Bequest in 1877 was a vast canvas by Hilton, 'Christ Crowned with Thorns'; by a singular stroke of misfortune, mocking the *Art-Union*'s prediction, the picture was destroyed in the Tate Gallery flood of 1928. Perhaps there is some truth in Leslie's claim, but nonetheless it is at variance with Chantrey's actions during his lifetime.

So far as we know Chantrey never bought a picture from Hilton. Instead, the first sign that he intended putting his growing fortune at the disposal of his fellow artists came when he bought a painting by Turner off the walls of the Academy exhibition of 1822. It was the first picture sold by Turner from a public exhibition in four years, and in its modest pretensions (it was called 'What You Will!' and showed figures in a garden landscape inspired by Shakespeare's *Twelfth Night*) it chimed exactly with Chantrey's realistic view of the limits artists should put upon their ambitions. A year later he signified his approval of David Wilkie's handling of a grand historical subject – 'The Entrance of George IV at Holyrood House' – successful just because it avoided the rhetorical cliches of the 'Grand Style' and yet was determinedly modern:

> although it may not be proper to dignify it by the term classical – still in my estimation it is a style that ought to be encouraged because it is in such compositions posterity will find legitimate English art. The Gods of the Greeks and the Saints of the Romans have had their day and before talent can be found to produce works of equal merit in those particular departments of art a national necessity for such works must exist.

The essential ingredient for success which Chantrey identified in Turner's and Wilkie's work (an example of which he later possessed) did not blind him

to the merits of those who distinguished themselves as history painters. He owned a small picture by Benjamin West; in about 1826 he guided a potential patron, without success, towards the first major exhibited but unsold painting by William Etty (1787–1849) and at the de Tabley sale in 1827 he bought a canvas by Henry Fuseli (1741–1825), one of the wilder and more obsessive talents of the English School. A reaffirmation of his belief in the peculiar genius of the native school came with his 'purchase', at the 1828 Academy exhibition, of John Constable's oil 'Hampstead Heath: Branch Hill Pond' (now in the Victoria and Albert Museum) but, curiously, he never paid for it and the artist sold it to another patron. Other painters who were represented in his collection, A.W. Callcott and Thomas Creswick (1811–1869) with characteristic examples of their landscapes, and Thomas Stothard (1755–1834) with a small religious subject, offer further evidence of his devotion to a quintessentially 'British' art. It was a devotion which undoubtedly guided the provision in his will that his Bequest should only be used in purchasing works of art 'entirely executed within the SHORES OF GREAT BRITAIN' (the capitalization is Chantrey's). What is more, Chantrey's provision stands as a confident rebuttal of the view, which since the eighteenth century had had a vogue among continental art historians and philosophers (J.J. Winckelmann in particular), that the cold, cloudy, damp English climate was, unlike the clear, bright atmosphere of Greece, for example, quite inimical to the production of great art.

The history of Chantrey's Bequest and the part it continues to play in the development of the National Gallery of British Art at the Tate would be incomplete without mention of another collection of nineteenth century British art which is also to be found there. It consists of about one hundred and fifty paintings and sculptures, chiefly bought from the leading artists of the day (but also including works by Reynolds, Wilson and Gainsborough) between the mid-1820s and late 1840s by a single collector, Robert Vernon; it represents one of the few sustained attempts by a single individual to supply the kind of patronage which artists were still crying out for in the wake of the de Tabley sale. By bequeathing it to the nation in 1847 Vernon, at a stroke, made up the deficiency in the National Gallery's representation of British Art which had been all too evident to the informed observer since its foundation in 1824. Vernon had fixed on his plan by the mid-to late-1830s, but knowing of Chantrey's own intentions, he enlarged his scheme to complement them. He set aside £70,000 for the future purchase of pictures and for the assistance of old and unsuccessful artists; and he planned to establish fellowships for artists, four or five years in length, with an allowance of £200 per annum, to enable them to pursue their studies in what Chantrey's biographer termed 'the higher, though less popular branches of art, without dread of discour-

agement through poverty' – a provision made, perhaps, with Hilton's fate in mind. Regrettably, Vernon later changed his mind, his intentions were never put into effect and so Chantrey's Bequest stands as the only living testimony of an artist's and patron's desire to assist future generations of British artists in perpetuity.

The Aftermath

'Works of Fine Art of the highest merit . . .' *Chantrey's Will*, 1840

Chantrey died suddenly on 25 November 1841 at the age of sixty. His body lay in state, in the small gallery designed by Soane which was attached to his workshop, surrounded by works from his own hands, and by casts taken from the greatest antique statues and from Canova's sculptures. During his lifetime he designed and had prepared his own tomb in his native parish of Norton near Sheffield (a forcible reminder of the example set by Canova) and it was to this that his body was borne for burial on 6 December.

All Chantrey's affairs were left in good order having been comprehensively dealt with in a will made in December 1840. Only one aspect of this need concern us here, and that was the fate of all his investments and the interest accruing from them. At Chantrey's death the investments seem to have totalled about £105,000 – which in present day terms is roughly the equivalent of £2.5 million – and they were to be managed by three trustees, one of whom was the sculptor's confidant and fellow Academician, the painter George Jones. The income was to be paid to Mary Ann, Chantrey's widow, for the remainder of her life, unless she remarried. After her death, or remarriage, the will specified that this residuary estate was to be in the trusteeship of five individuals, two of whom were to be the President and the Treasurer of the Royal Academy.

When Lady Chantrey died in January 1875, there were only two trustees of the will, one of whom, Sir Francis Grant, the President of the Academy and a rather dull portrait painter, had been appointed just before her death; but by 5 February, all five trustees had been appointed, with E.M. Barry, an architect who was Treasurer, being the other Academician. By now, the income from the estate was to be divided in two ways. The least significant, at least in monetary terms, but nonetheless of immense symbolic importance, was a small annuity for the benefit of the vicar and parishioners of Norton, the continued payment of which depended upon the sculptors' tomb being, in the words of the will, 'preserved from destruction'. To this end the present day Trustees of the Chantrey Bequest have the tomb at Norton regularly surveyed to ensure that it is not deteriorating.

Far more important, of course, was the purpose to which the rest of the income was put and this was specified in Chantrey's will as follows.

The income was to be used for the 'encouragement of British Fine Art in painting and sculpture' by means of purchases 'of works of Fine Art of the highest merit in painting and sculpture that can be obtained either already executed or which may hereafter be executed by Artists of any nation provided . . . the same shall have been entirely executed within the shores of Great Britain.' The first purchases, one sculpture and seven paintings, were made in 1877. The fact that Lady Chantrey outlived her husband by thirty-three years meant that a whole generation of contemporary British artists working between the 1840s and 1870s, for example the Pre-Raphaelites, failed to gain any benefit from Chantrey's generous patronage. Indeed it could be argued that by recommending to the Chantrey Trustees that they purchase a picture by William Hilton as their first acquisition, the Council of the Royal Academy was acknowledging the primacy of the art of Chantrey's own period over that of their own time. Certainly it has to be said that the view of contemporary British Art which they took at this very moment was conservative and 'safe'. Even within the confines of the 1877 Summer exhibition which they apparently judged sufficient for their purposes, the Council chose not to recognise the merits of the severer kind of English realism, for example R.W. Macbeth's 'Potato Harvest in the Fens'. Even more telling, since it opened at exactly the same time as the Summer exhibition, and not one of its participants was ineligible for consideration by the Academy Council, the first exhibition at the newly opened Grosvenor Gallery seems to have played no part in their deliberations, unless it was to scrupulously ignore it. But here, most notably, were to be found works by J.M. Whistler (1834–1903), including the remarkable 'Nocturne in Black and Gold: The Falling Rocket' priced at 200 guineas (now in the Detroit Institute of Arts).

Chantrey's will expressed the hope that 'the Government or the Country will provide a suitable and proper building or accommodation' for the works bought with his money, but early hopes that a special gallery could be built failed to materialise. Chantrey, like Turner, did not want any of his money to be spent on the building. As the collection has grown, this has resulted in regular reviews as to the proper home for 'a public national collection of British Fine Art in painting and sculpture'. The first purchases were housed in the South Kensington Museum (later the Victoria and Albert) and some regional galleries. When the Tate Gallery opened in 1897, the collection was transferred to Millbank. As the collection has grown, it has naturally raised problems about its custody and display. In 1954 the Chantrey Trustees considered the possibility of offering works to regional galleries or of using

rooms in large country houses near to London, e.g. the stables at Woburn.

The ensuing relationship between the Tate Gallery and the Royal Academy over the Chantrey Bequest purchases has been a delicate one because the Royal Academy is responsible for the selection of works and the Tate Gallery is responsible for the preservation and exhibition of those works. Until the Tate Gallery was granted its own Board of Trustees in 1917, it was not even in a position to consider offering recommendations about Chantrey Bequest purchases although it was empowered to accept them for its collection. The Chantrey Trustees and the Royal Academy were disappointed that the new Board of Tate Trustees did not include any artists, and they asked the Treasury for artists' representation on the Tate Board. This was instituted in 1920, with four artist trustees, Sir Aston Webb, Charles Sims, D.Y. Cameron and Muirhead Bone, appointed. In 1922 two artist members of the Tate Board of Trustees were invited to attend the painting and sculpture subcommittees which the Royal Academy had instituted, in the early years of the twentieth century, to consider Chantrey Bequest purchases.

The painting and sculpture subcommittees, consisting of three painter members of the Academy and three sculptor members who submitted proposals for purchases to the Academy Council and thus the Chantrey Trustees, had been set up in response to the 1904 Select Committee of the House of Lords enquiry into the administration of the Chantrey Bequest. By 1904 the collection totalled 106 works and, as it always had been, was displayed as a separate collection at the Tate Gallery (see fig.2), D.S. MacColl, an influential art critic, began to complain in the press about the nature and quality of the purchases. MacColl argued that works by Whistler, Burne-Jones, Rossetti, Madox Brown, Holman Hunt should have been bought because they were of higher merit than say the painters R. Stark, L. Rivers and G. Cockram '(whoever he may be)'. MacColl also felt that the Chantrey Trustees were confining themselves too tightly to the purchase of living British artists

fig.2 'The Chantrey Rooms at the Tate Gallery in 1899: Gallery 7' (now Gallery 30). Reproduced from *The Art Journal* 1899

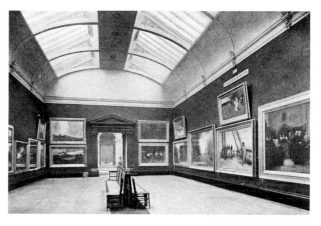

and current Royal Academicians at that. MacColl argued that the terms of Chantrey's bequest were so wide that 'the Trustees would be within their right technically in purchasing sculptures or paintings executed in England by foreigners, in Roman, Medieval or Renaissance times.' The general sense of the project was no doubt against so wide a range, but if Hilton was eligible (Hilton died in 1839 and his work was bought in 1877) there was no reason against going back at least as far as Hogarth. Perhaps recognising the validity of MacColl's argument, a painting by William Holman Hunt (1827–1910), was purchased by the Chantrey Trustees in 1919.

Although the Royal Academy enjoyed an autonomous existence and did not have to respond in any way to the deliberations of the Select Committee of the House of Lords enquiry into the administration of the Chantrey Bequest, it decided to widen the scope for suggestions about proposals by setting up the two subcommittees and it suggested that Chantrey purchases could be made from dealers, auctions and private collectors as well as the usual source of the Royal Academy summer exhibitions.

Relations with the Tate Gallery over proposals for purchases were amicable from 1922 until 1927. In that year and the following, when the Tate's representatives did not attend the meetings of the subcommittees for discussion about purchases, no works were bought for the Chantrey collection. Relations were restored, however, on the election of Sir William Llewellyn as President of the Royal Academy at the end of 1928, but they went sour again in 1956 when the Academy bought Maurice Lambert's over life-size bronze figure of Margot Fonteyn from the Summer exhibition for the Chantrey collection and the Tate Trustees declined to accept it. Currently, the Tate Gallery has an influence on which works are purchased for the Chantrey collection but it has no formal rôle in the decision on which works these should be.

Because Chantrey's will did not stipulate that work bought had to be by British artists, only that it had to have been made within the shores of Great Britain, it allows for the purchase of work by foreign artists. D.S. MacColl in 1904 urged that 'artists not of English birth [but] who have worked in England' of the calibre of 'Dalou, Legros, Fantin-Latour, Whistler, Degas . . . and Claude Monet, all men of deserved European reputation' should be considered for purchase. To date, only one work by a foreign artist of European reputation has been bought under the terms of the Bequest and that was Derain's 'The Pool of London' painted in London in 1906 and bought through a London dealer's gallery in 1951. It is amusing to speculate that Kokoschka (1886–1980), Mondrian (1872–1944), and Gabo (1890–1977), all of whom have created a body of work within the shores of Great Britain, could be represented in the Chantrey Collection.

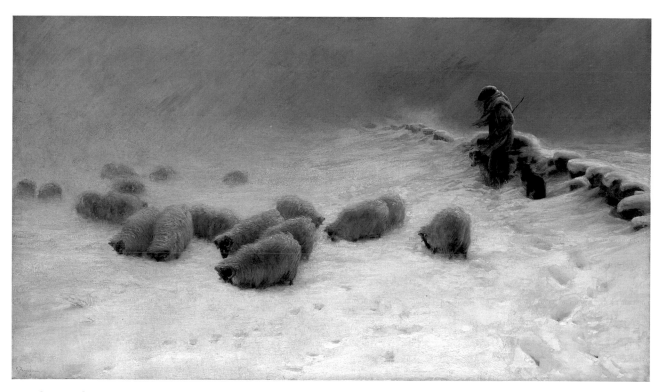

Joseph Farquharson **The Joyless Winter Day** *c.*1883
(cat.1)

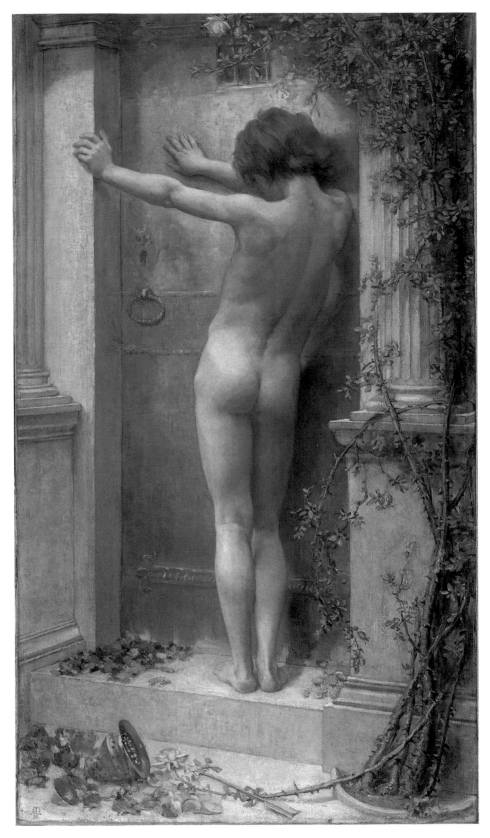

Anna Lea Merritt **Love Locked Out** 1889
(cat. 3)

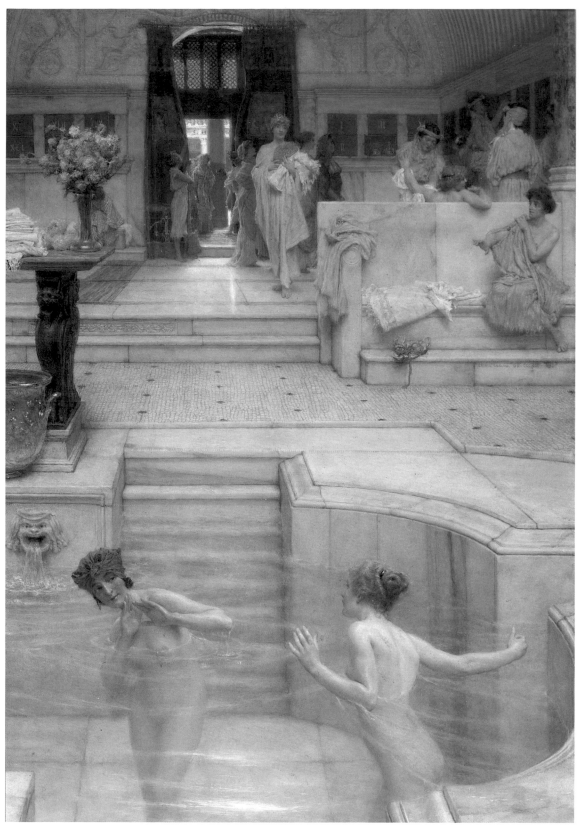

Sir Lawrence Alma-Tadema **A Favourite Custom** 1909
(cat.7)

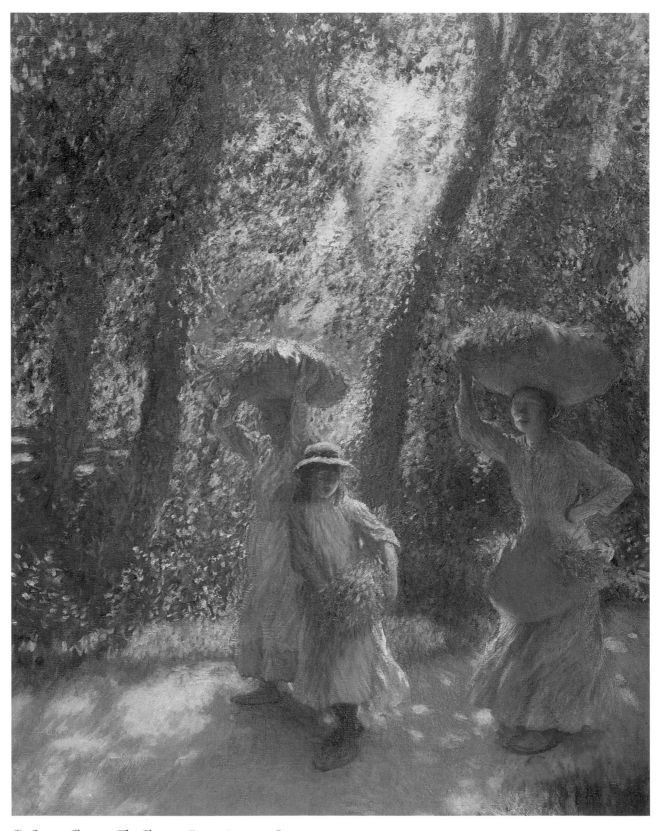

Sir George Clausen **The Gleaners Returning** 1908
(cat.6)

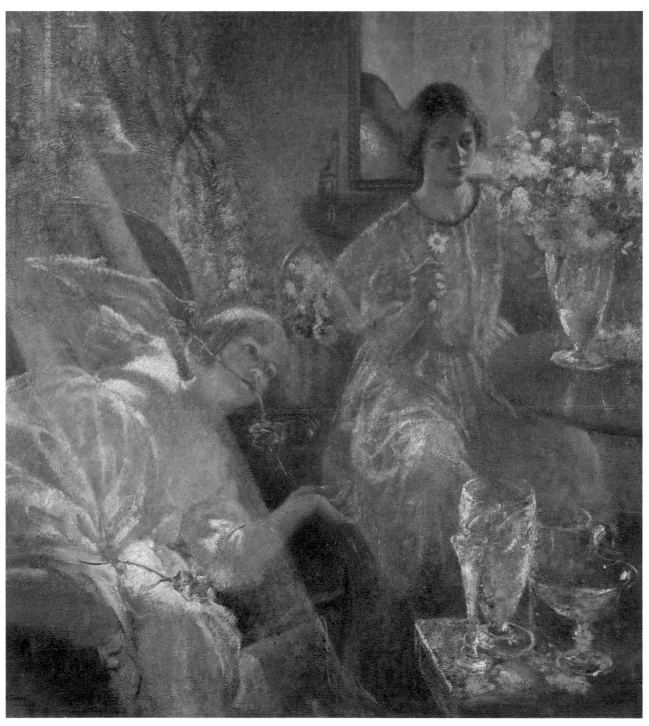

Henry Tonks **Spring Days** *c.*1926–9
(cat.13)

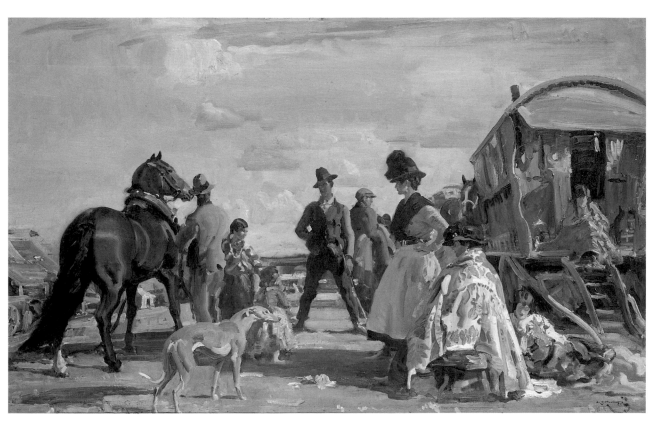

Sir Alfred Munnings **Epsom Downs – City and Suburban Day** 1919
(cat.10)

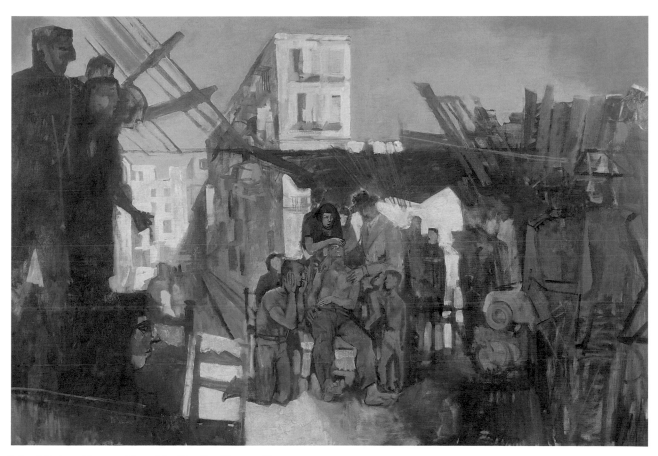

John Minton **Composition: The Death of James Dean** 1957
(cat. 34)

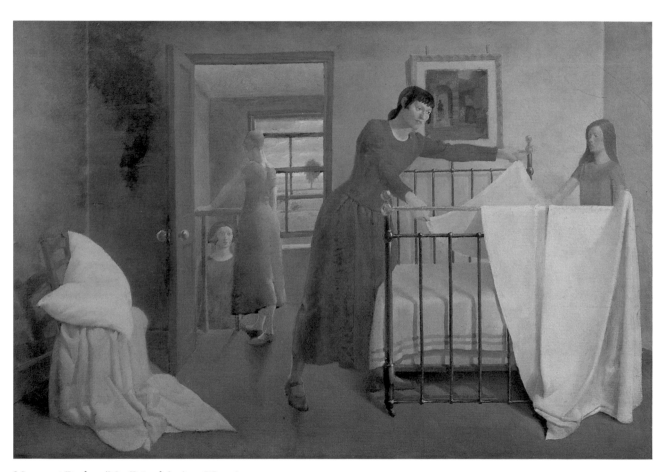

Margaret Barker (Mrs Pringle) **Any Morning** *c.*1929
(cat.12)

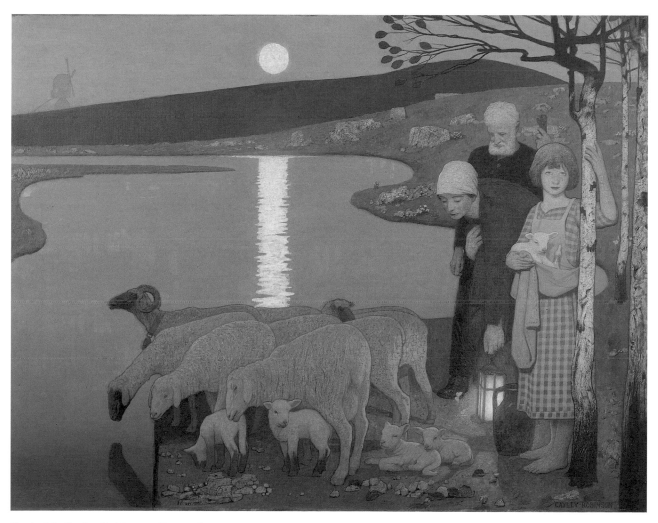

Frederick Cayley Robinson **Pastoral** 1923–4
(cat.11)

Gilbert Spencer **A Cotswold Farm** 1930–1
(cat.14)

Dame Laura Knight **Spring** 1916–20
(cat.18)

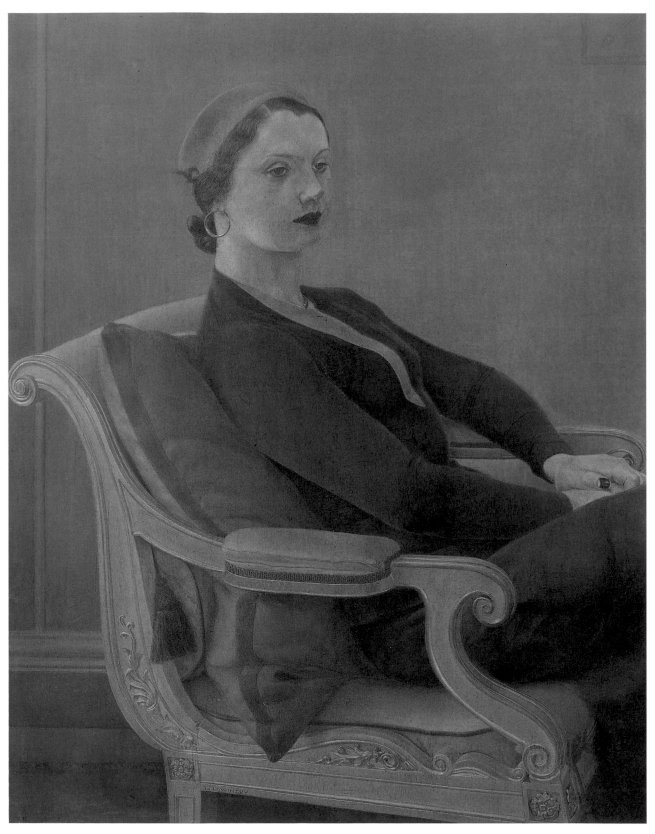

Thomas E. Lowinsky **Mrs James McKie** 1935
(cat.23)

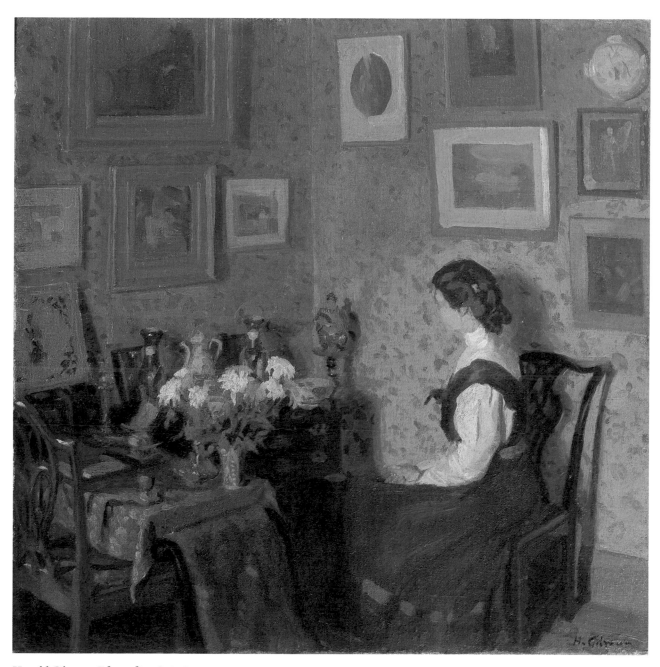

Harold Gilman **Edwardian Interior** *c*.1907
(cat.31)

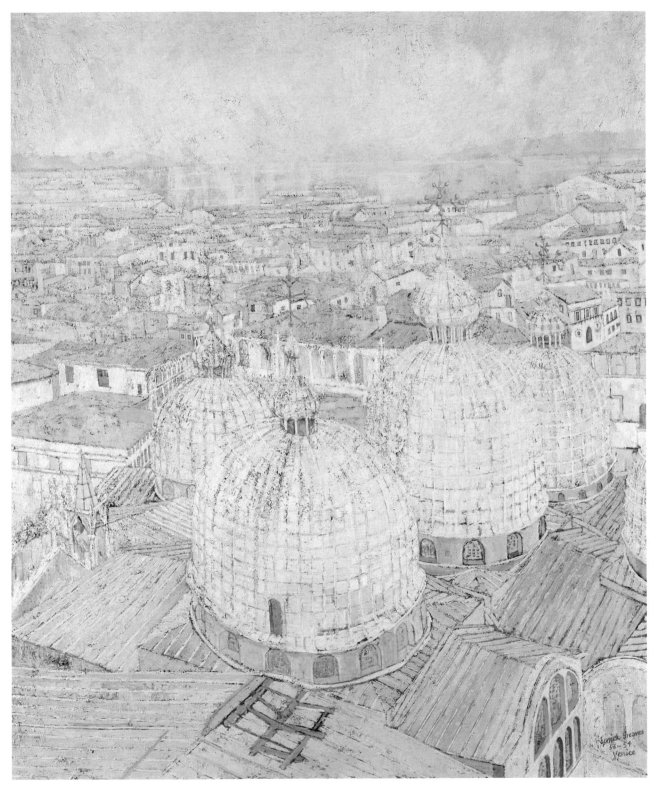

Derrick Greaves **Domes of Venice** 1953-4
(cat. 30)

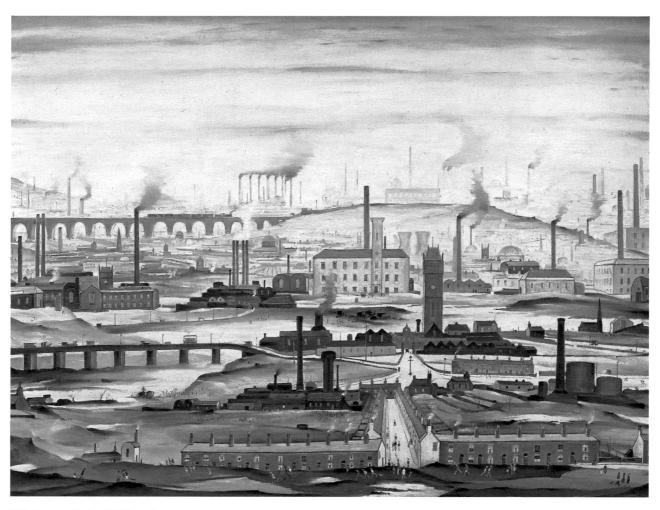

L.S. Lowry **Industrial Landscape** 1955
(cat.32)

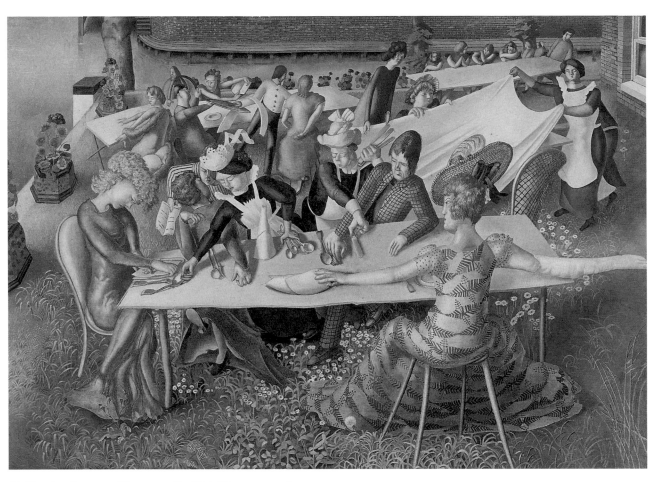

Sir Stanley Spencer **Dinner on the Hotel Lawn** 1956–7
(cat. 35)

Tristram Hillier **Alcañiz** 1961
(cat.38)

Victor Pasmore **The Quiet River: The Thames at Chiswick**
1943–4 (cat. 36)

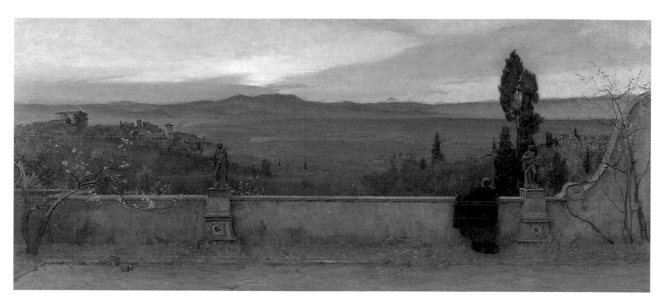

Matthew Ridley Corbet **Val d'Arno: evening** *c.*1901
(cat.4)

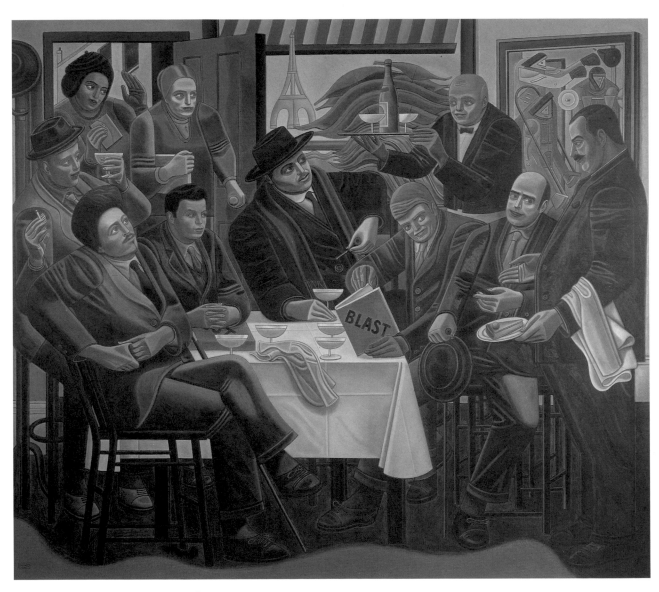

William Roberts **The Vorticists at the Restaurant
de la Tour Eiffel: Spring, 1915** 1961–2
(cat. 39)

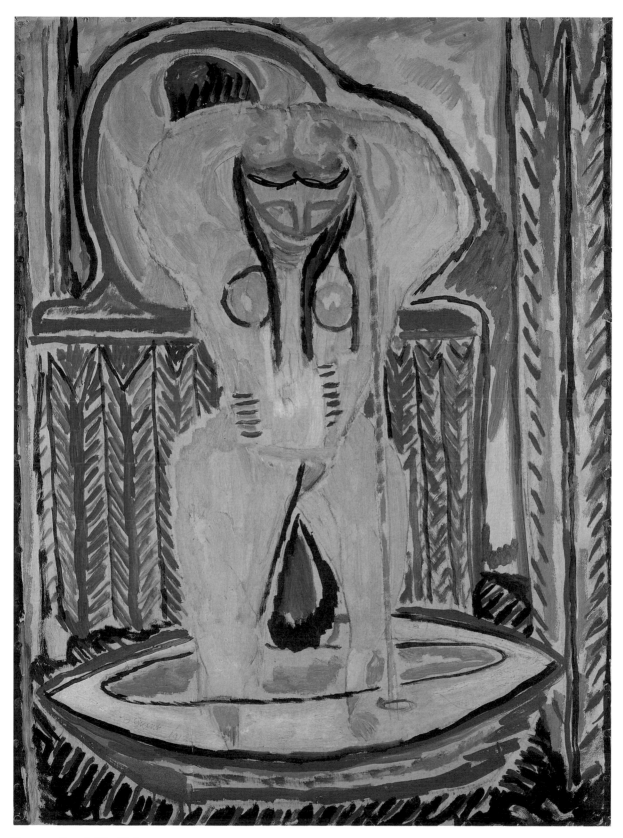

Duncan Grant **The Tub** *c.*1913
(cat.43)

Ivon Hitchens **Coronation** 1937
(cat.42)

Elizabeth Blackadder **Still Life with Pomegranates** 1963
(cat.45)

Adrian Berg **Gloucester Gate, Regent's Park, May 1982**
1982 (cat.54)

Catalogue

Measurements are in millimetres, followed by inches
and are given in the order: height, width, depth.
Works illustrated in colour are marked*

JOSEPH FARQUHARSON
1846–1935

1 *The Joyless Winter Day** c.1883

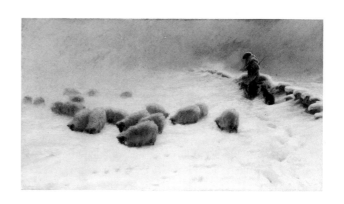

Oil on canvas 1041 × 1803 (41 × 71)
Purchased from the artist in 1883 for £250

Farquharson combined a career as a painter, of mainly Scottish winter landscapes, with his inherited rôle as Lord of Finzean estate, Aberdeenshire. He spent some time working in Paris in the early 1880s under the painter Carolus-Duran and there he learnt to paint from the landscape, setting up his easel and canvas in the open air. Back in his native Scotland, he devised a way of working in the open air of a colder climate, by having some wooden painting huts on wheels made. These were fitted out with a paraffin stove and a large glass window, which made painting in the midst of a Scottish snow blizzard possible. 'The Joyless Winter Day' was painted in these conditions, which helped to capture the remarkably real effects of stormy winter weather. Besides the sensible painting huts, Farquharson commissioned model sheep from a local sculptor, William Wilson of Monymusk. Farquharson sent a snowy landscape scene to the Royal Academy every year between 1894 to 1925 (excepting 1914); the very first of this series was 'The Joyless Winter Day'.

WILLIAM LOGSDAIL
1859–1944

2 *St Martin-in-the-Fields* 1888

Oil on canvas 1435 × 1181 (56½ × 46½)
Purchased from the artist in 1888 for £600

Logsdail's reputation during his lifetime was based largely on his paintings of scenes of town life, all of which had a strong architectural element as a backdrop. To paint St Martin-in-the-Fields, Logsdail set up his easel in a lorry stationed for weeks at the kerb-side by special permission, and under the protection of the Metropolitan Police, this being necessary to restrain the curious public. He painted during a severe winter. A tarpaulin was suspended above him and his easel to provide shelter from rain and sleet, and straw was spread on the floor of the lorry to prevent his feet freezing. Apparently, Logsdail set out with the intention of painting a snow scene, but the snow did not fall while he was working on the picture. When the work was exhibited, an unknown commentator noted that 'if ever a photograph represents colour, this is what would be the result'.

ANNA LEA MERRITT
1844–1930

3 *Love Locked Out** 1889

Oil on canvas 1156 × 641 (45½ × 25¼)
Purchased from the artist in 1890 for £250

This was the first work by a woman to be bought for
the Chantrey Bequest. The artist was widowed in 1877
after only three months of marriage and she produced
a design for a bronze relief headstone for her and her
husband's grave with the subject of 'Love Locked Out'.

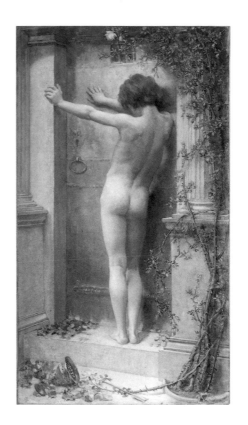

> After waiting ten years, as it seemed that I never
> could afford the expense of bronze casting, I painted
> and exhibited it in 1890. In my thoughts the closed
> door is the door of the tomb. Therefore I showed the
> dead leaves blowing against the doorway and the
> lamp shattered . . . I feared people liked it as a
> symbol of forbidden love, while my love was waiting
> for the door of death to open and the reunion of the
> lonely pair. I only beg anyone who likes this picture
> to remember that Henry Merritt inspired it.

Anna Lea Merritt survived her artist husband by
fifty-three years.

MATTHEW RIDLEY CORBET
1850–1902

4 *Val d'Arno: evening** c.1901

Oil on canvas 908 × 2089 (35¾ × 82¼)
Purchased from the artist in 1901 for £526

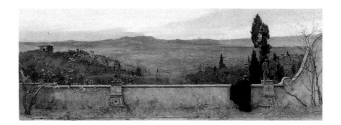

Corbet lived in Italy from 1880–84 and during this
period he turned away from portrait painting, with
which he had started his career, to take up landscape
painting. There he befriended an Italian painter, Giov-
anni Costa, and in the 1880s and 90s painted with
him along the Italian Tuscan coast, particularly
around the estuary of the River Arno. 'Val d'Arno:
evening' shows a panoramic view of the Arno valley,
with the city of Florence in the distance seen from the
hill-town of Fiesole. All is suffused with the fading
evening light of an early spring day.

HAROLD SPEED
1872–1957

5 *The Alcantara, Toledo, by Moonlight* 1894

Oil on canvas 635 × 914 (25 × 36)
Purchased from the artist in 1905 for £105

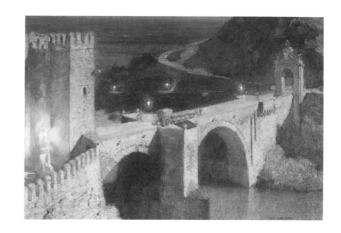

Harold Speed was a society portrait painter who exhibited all his life at the Royal Academy, and avoided the membership of any modern grouping of artists. He first trained, for a short time, as an architect, and his landscapes are often views of towns or particular buildings. At the Royal Academy schools he was one of the most successful pupils during the 1890s, winning gold medals and in 1893 a travelling scholarship. He went to Italy with this scholarship, and from there visited Spain, where he painted this view of the famous mediaeval bridge at Toledo seen by moonlight.

'The Alcantara' became Speed's best known work, although it was painted when he was only twenty-two. Most of his time was devoted to commissioned portraits, and as a large gathering of his paintings has not been seen since his memorial exhibition in 1959 he is now scarcely remembered. However, he painted frescoes in 1895 in the basement room of the Royal Academy, now the cafeteria, where they are still to be seen.

SIR GEORGE CLAUSEN
1852–1944

6 *The Gleaners Returning** 1908

Oil on canvas 838 × 660 (33 × 26)
Purchased from the artist in 1908 for £200

Clausen studied at the South Kensington School of Art and from his student years he was a great admirer of Dutch painting. Living in a very rural part of Hertfordshire in the 1880s, and learning of the work of contemporary French plein-air artists such as Jules Bastien-Lepage, Clausen turned to painting the landscape and the field workers around him. He wrote how he liked to paint 'people doing simple things under good conditions of lighting'.

During a long and distinguished career Clausen constantly extended and expanded his visual repertoire. In 'The Gleaners Returning' the realism of Lepage is augmented by the Impressionism of Monet. The setting is probably rural Essex which Clausen would frequently visit from his London home. A contemporary report described the picture as 'one of the finest of those problems of light which have so often engaged the artist'.

SIR LAWRENCE ALMA-TADEMA
1836–1912

7 *A Favourite Custom** 1909

Oil on wood 660 × 451 (26 × 17¾)
Purchased from the artist in 1909 for £1750

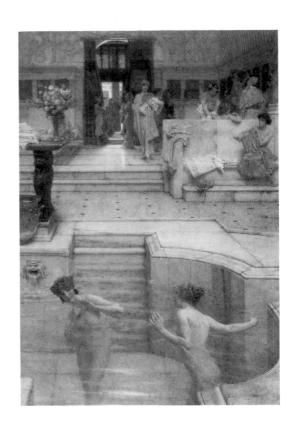

Sir Lawrence Alma-Tadema was one of a group of
artists who, whilst working in Victorian England,
looked to Classical Greece and Rome for inspiration.
Born in the Dutch province of Friesland, Tadema was
first apprenticed to the law but entered the Antwerp
Academy in 1852. A visit to Pompeii and Hercu-
laneum in 1863 initiated a life-long love affair with the
classical world. Tadema settled in England in 1870,
becoming a naturalised subject in 1873.

His art had its detractors (*Punch* dismissed him
as 'marbellous') but in over four hundred works he
displayed consistent brilliance in surface renditions,
immaculately researched settings and breathtaking
compositions which frequently belie their scale.

This painting is one of Tadema's last bathing scenes.
The architectural setting is based on that of Pompeii
and was taken from a photograph in Tadema's collec-
tion.

CHARLES SHANNON
1863–1937

8 The Lady with the Amethyst 1915

Oil on canvas 610 × 597 (24 × 23½)
Purchased from the artist in 1916 for £300

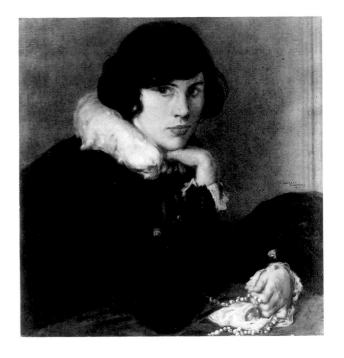

Shannon was a painter of figure subjects and portraits,
an illustrator and a collector, who enjoyed a high
reputation during his lifetime as much in France as in
England. In 1882 at Lambeth School of Art he met
Charles Ricketts who was to become his life-long
friend. Ricketts said of Shannon that Titian and Velas-
quez must have stood as sponsors at his birth, and
certainly the artist's debt to these Old Masters is evi-
dent in his portraits and figure compositions. The sitter
for this portrait is Miss Hilda Moore, who also appears
in another of his works 'Lady in Black' of 1918, wear-
ing a similar costume. In 1929 Shannon fell from
a ladder while hanging a picture and never fully
recovered.

GLYN PHILPOT
1884–1937
9 *A Young Breton* 1917

Oil on canvas 1270 × 1016 (50 × 40)
Purchased from the artist 1917 for £500

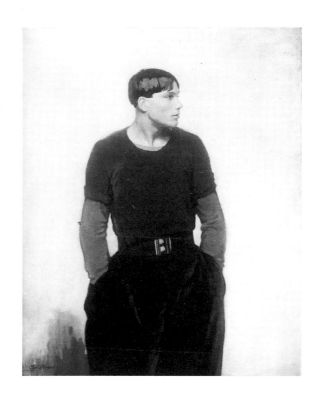

Philpot was both a painter and a sculptor. His subjects included commissioned society portraits, portraits of friends, and religious, mythological and allegorical subjects. 'A Young Breton' is probably a portrait of a friend; the sitter's name is believed to be Guillaume Rolland and the work was painted in London. Philpot admired Spanish art, especially the work of Velasquez, and he visited Spain in 1906 and 1910. From Spanish painters he learnt how to use black and strong tonal contrasts in his paintings, which he puts to good effect in this portrait. 'A Young Breton' is a notable example from a series of full length or three-quarter length portraits of men which Philpot produced in the years 1912 to 1920. All the portraits show the figure posed in a simple setting and with great emphasis given to their silhouette.

SIR ALFRED MUNNINGS
1878–1959
10 *Epsom Downs – City and Suburban Day** 1919

Oil on canvas 794 × 1283 (31¼ × 50½)
Purchased from the artist in 1920 for £700

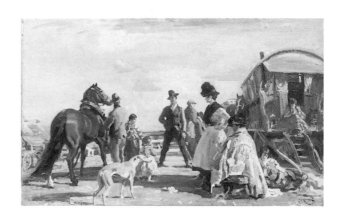

Munnings is remembered both for continuing the tradition of English sporting subjects with his skill in painting horses in sunlight, but also for his extreme dislike of modern painting while he was President of the Royal Academy (1946–9). Early in his career he lived in Cornwall and learnt there the habit of painting out of doors, but with the high keyed colours of Augustus John. John had popularised gypsy subjects, and here Munnings shows a group of gypsies at Epsom races.

Munnings wrote of his painting:

Never have I quite felt the alluring, infectious joy of the races, the tradition of Epsom, as I did in that first year after the war, 1919. The hill, the crowd on either side of the course; the gypsies, the caravans were Edwardian – Victorian – eighteenth century. A picturesque swarthy crowd, still retaining their carved-and-gilded caravans. The costumes of the women surpassed all dreams. Large, black, ostrich plumed hats, black ringlets, big ear-rings. The picture was painted during a second visit to that same Hampshire hop-picking country where I had worked before the war. The picture was begun and finished under stress and trial, in a wet season.

FREDERICK CAYLEY ROBINSON
1862–1927

11 *Pastoral** 1923–4

Oil on canvas 902 × 1168 (35½ × 46)
Purchased from the artist in 1924 for £420

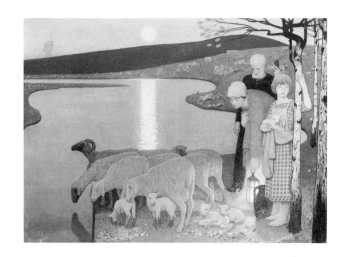

After studying at the Royal Academy schools, Robinson lived on a boat, which he helped to build from 1889 to 1891 and this resulted in many paintings in which boats, the sea and rivers appear. The figures in his compositions are usually silent and wistful and intent on embarking upon journeys, often by boat. No journey is apparent in 'Pastoral' but the old man and two women appear with their flock at the very edge of a river bank as if waiting for someone to arrive. Robinson's admiration for Fra Angelico and Italian Renaissance frescoes led him to adopt a flattened decorative style of painting with a strong insistence upon contours, which can be seen to advantage in 'Pastoral'.

MARGARET BARKER (Mrs Pringle)
born 1907

12 *Any Morning* c.1929

Oil on canvas 622 × 914 (24½ × 36)
Purchased from the artist in 1929 for £40

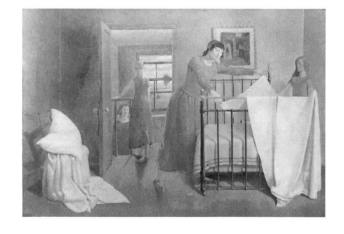

'Any Morning' was purchased by the Trustees of the Chantrey Bequest while Margaret Barker was still a student at the Royal College of Art (1925–9). It was sent for exhibition at the New English Art Club in 1929 under pressure from Professor Randolph Schwabe at the RCA although the artist herself had reservations about the work. Margaret Barker painted figuratively, capturing her subjects in ordinary everyday tasks. In 'Any Morning', the main incident is of a young girl helping a women to make up a bed while an open door leads to a secondary scene where two women are held in conversation. This double scenario is echoed in the picture on the wall which is taken from Pieter de Hoogh's 'The Courtyard of a House in Delft', 1658, in the National Gallery, a painting Barker must have admired.

HENRY TONKS
1862–1937

13 *Spring Days** c.1926–9

Oil on canvas 864 × 813 (34 × 32)
Purchased from the artist in 1931 for £800

Henry Tonks had two very successful careers, firstly as a surgeon and secondly as an artist. His medical training led him into surgery – he became a Fellow of the Royal College of Surgeons in 1888 and Demonstrator in Anatomy at the London Hospital Medical School in 1892. In 1888 he began attending evening class at the Westminster School of Art, which led him into the arts. He was appointed assistant to Professor Fred Brown at the Slade School of Art in 1892 when he gave up medicine and subsequently in 1918–1930 was Slade Professor. His medical training had equipped him with a knowledge of anatomy exceptional among artists.

'Spring Days' is characteristic of his luminous and tender domestic paintings which contrast starkly to the watercolour studies of facial wounds which Tonks made while investigating the possibilities of plastic surgery during the 1st World War. According to Joseph Hone in his 1939 biography of Tonks 'Spring Days' was begun in 1926 and partly repainted using different models, one of whom was Mrs Laconte who modelled for the girl arranging the flowers from the age of 9 to about 13.

GILBERT SPENCER
1892–1979

14 *A Cotswold Farm* 1930–1

Oil on canvas 1410 × 1841 (55½ × 72½)
Purchased from the artist in 1932 for £367–10s

The artist wrote (20 April 1958) that this picture was begun at his house in Hampstead in about March 1930 and was completed by April 1931 in Ladbroke Grove, where he had moved after his marriage.

> The picture was entirely imaginary and no studies or drawings were made from nature for it. This would explain a number of things in it that are not Cotswold in character. I have often used agricultural settings, mostly secondary in which to place my designs. In this one, as the result of my many visits to [Andoversford] in the Cotswolds to stay with [my friends] Austin and Vera Lane Poole and my experiences from painting landscapes there, I decided to use the colour and stone of the Cotswolds for this picture.

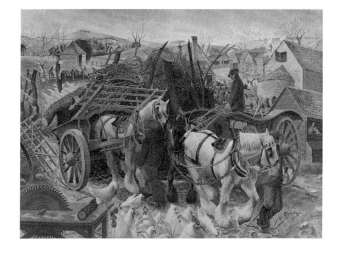

SIR GERALD KELLY
1879–1972

15 *The Jester (W. Somerset Maugham)* 1911

Oil on canvas 1016 × 762 (40 × 30)
Purchased from the artist in 1933 for £500

This portrait was painted in July 1911 at the artist's studio in 7 William Street, Knightsbridge, and was the third of many portraits of Somerset Maugham painted by Kelly. The first and the second were painted in 1907, soon after the two men became friends. In 'An 80th Birthday Tribute to Somerset Maugham' (*Sunday Times*, 24 January 1954) Kelly wrote:

> I first met Somerset Maugham in the garden of a villa which his elder brother had taken for the summer at Meudon. I was struck by the fact that his whole face was just one colour – very pale – and that his eyes were like little pieces of brown velvet – like monkey's eyes. I thought he looked very distinguished.

Somerset Maugham (1874–1965), the playwright and novelist, was already well known when his portrait was painted. Maugham probably gave the sittings to Kelly as an encouragement, since a portrait of him would inevitably be talked about. Both men associated with high society, and it is appropriate that Maugham appears as an Edwardian dandy.

SIR JACOB EPSTEIN
1880–1959

16 *Albert Einstein* 1933

Bronze 432 × 279 × 254 (17 × 11 × 10)
Purchased from the artist in 1934 for £525

As well as carving monumental, often controversial sculptures, Epstein modelled many portrait busts of famous figures, which show great psychological insight. This bust of Professor Albert Einstein (1879–1955), the mathematician and physicist, originator of the Special Theory of Relativity 1905, Laws of the Photoelectric Effect 1905, and the General Theory of Relativity 1917, was modelled at a refugee camp near Cromer to which Einstein had fled in 1933 when there were rumours of his intended assassination in Berlin.

Epstein described the sittings in *Let There be Sculpture* (1940, p.94):

> . . . his wild hair floating in the wind. His glance contained a mixture of the humane, the humourous, and the profound. This was a combination that delighted me. He resembled the ageing Rembrandt.

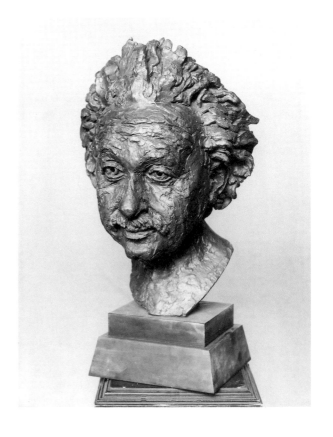

AUGUSTUS JOHN
1878–1961
17 *Lord David Cecil* 1935

Oil on canvas 921 × 718 (36¼ × 28¼)
Purchased from the artist in 1935 for £800

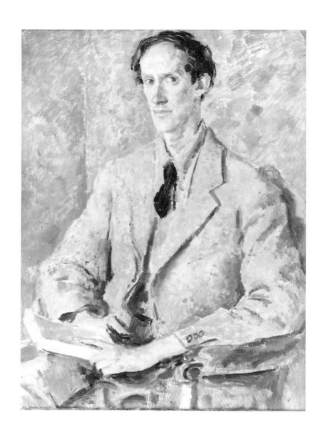

The Tate Gallery has acquired seven paintings by Augustus John through the Chantrey Bequest, six portraits and a still life of flowers. The portrait of Lord David Cecil was the first of these, bought in the year it was painted and exhibited at the Royal Academy, where John had been an Academician since 1928. He often chose his own sitters rather than taking commissions, and painted artists and literary figures of his own and younger generations. Lord David Cecil, a younger son of the 4th Marquess of Salisbury, was a literary historian who in 1948 became Professor of English Literature at Oxford. At the time of this portrait he had already published biographies of William Cowper (1929), Sir Walter Scott (1933) and Jane Austen (1935).

The colours of John's portrait are remarkably quiet and close in tone, unlike others by him of this date, and the drawing of the head is carefully modelled, while the hands are unfinished.

DAME LAURA KNIGHT
1877–1970
18 *Spring** 1916–20

Oil on canvas 1524 × 1829 (60 × 72)
Purchased from the artist in 1935 for £400

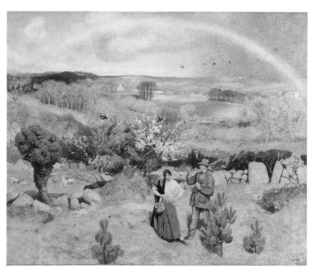

Dame Laura Knight is best known for her sketches of the circus and of the theatre, but for a period of ten years she lived in Cornwall and painted landscapes. The view is of the Lamorna valley near Newlyn. Laura and her husband, the portrait painter Harold Knight, had moved to Cornwall in 1907, at first living in Newlyn and then in St. Buryan, where 'Spring' was painted. The Knights were friendly in Cornwall with the artists A.J. Munnings, Lamorna Birch and Dod and Ernest Proctor. Laura Knight's smaller landscapes were intended to look casual and relaxed, but this large painting is more carefully designed, and was intended to express 'Spring' itself, with the figures as confident and fresh as the season. The models were neighbours and close friends of the Knights, Ella and Charles Naper. He was also an artist, and painted seascapes, and she made jewellery. Ella Naper often posed, either clothed or nude, for both the Knights. She was the model for the full length nude in Laura Knight's extraordinary self portrait of 1913 (National Portrait Gallery) where she appears in the background as if being painted by another.

JAMES McINTOSH PATRICK
born 1907

19 *Winter in Angus* 1935

Oil on canvas 756 × 1016 (29¾ × 40)
Purchased from the artist in 1935 for £157–10s

Born in Dundee, James McIntosh Patrick studied at Glasgow School of Art and while still a student commenced his career as an etcher and painter of landscapes and portraits. The artist described the evolution of this work:

The castle came because I had already made a painting and an etching of Powrie Castle and I thought it would make a good subject for a big picture. But in 'Winter in Angus' I created an imaginary viewpoint, up high. For the background – well I wanted a complicated background and at that time I was teaching on Fridays at Glenalmond and the background is the view from the Art Room window which I fitted in behind the Castle. I was looking for something for the foreground and I decided to put in the pigeon loft but apart from that the rest of the foreground is just invented. In those days – and I don't know how I did it – I had a way of putting on paint and then rubbing something all over it to soften the image and then sharpening it all up by careful reworking. I let the paint make the suggestions into something more solid. In other words these were abstractions which gradually were turned into realistic pictures.

DOD PROCTER
1892–1972

20 *Kitchen at Myrtle Cottage* c.1930–5

Oil on canvas 641 × 762 (25¼ × 30)
Purchased from the artist in 1935 for £73–10s

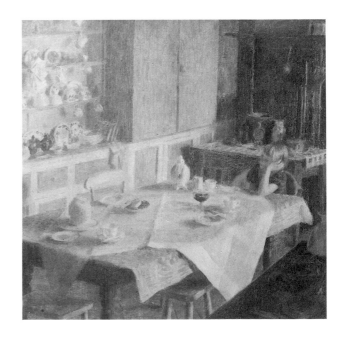

Dod Procter moved to Newlyn, Cornwall in 1907 to study at Stanhope Forbes's School, and apart from short periods, she spent the rest of her life there. Myrtle Cottage was her first home in Newlyn, and Laura Knight described in her autobiography *Oil Paint and Grease Paint* how the cottage, rechristened the 'Myrtage', was home to four girl art students – including Dod – known as 'the elite' and presided over by Mrs Shaw (Dod's mother). According to her account:– 'the Myrtage was the centre of aesthetic culture'. In this picture a child from the village is depicted in the kitchen.

In the early 1930s Procter's style became less sculptural, although she retained an interest in the play of light. A similar picture entitled 'In the Kitchen' shows the kitchen at North Corner, another cottage in Newlyn where she later moved with her artist husband Ernest.

ERNEST PROCTER
1886–1935
21 *The Zodiac* 1925

Oil on canvas 1524 × 1676 (60 × 66)
Purchased from the artist in 1936 for £367.10s

With his wife Dod, Ernest Procter formed a central part of the community of artists which flourished in and around Newlyn, Cornwall between 1900 and 1930. 'Essentially a decorator of spaces rather than a painter of framed pictures' was how a friend described him and 'The Zodiac' is one of the most ambitious of his decorative compositions. Dod Procter confirmed in a letter (12 October 1958) that her husband 'was much taken up with the subject and had written several poems about it'. At the Royal Academy's 1935 exhibition 'British Art in Industry' he exhibited a carpet designed with the signs of the Zodiac as a central motif. Ernest Procter has also painted the frame of this work with the zodiacal signs.

HAROLD KNIGHT
1874–1961
22 *A Student* c.1938

Oil on canvas 610 × 508 (24 × 20)
Purchased from the artist in 1938 for £315

Harold Knight is now, quite deservedly, less well known than his wife Laura, and this was already the case during his lifetime despite his success as a portrait painter. He sent portraits to the Royal Academy throughout his career, and rarely painted any other subject, although he showed a few landscapes there at first. This picture is unusual in his output in its modest title and its unidentified sitter, as almost all his portraits were commissioned by, or for, distinguished sitters. The sense that this is a model he is painting and not a commission is conveyed by the pose and downward glance, which are clearly not intended to denote high rank or achievement. The fashionable check jacket and tie-neck blouse, and the jewellery, are worn by the sitter with the least exuberance. The artist chose an absolutely central pose, evenly lit from both sides, so that the pronounced central parting of the hair emphasises the symmetry. It is the pose of a self portrait, with the result that the averted gaze has a slightly unnerving affect, and the meticulous technique appears a substitute for the lack of eye contact with the sitter.

THOMAS E. LOWINSKY
1892–1947

23 *Mrs James McKie* * 1935

Oil on canvas 571 × 445 (22½ × 17½)
Purchased from the artist in 1939 for £125

Lowinsky did not paint commissioned portraits; instead he worked from his friends or professional models. He liked to depict genteel women in sympathetic surroundings and usually chose a range of muted low-key colours for them and their setting. A colleague, Sir Francis Meynell, wrote of Lowinsky's pictures after his untimely death, 'as well founded, as well begun, having their roots in his imaginative, scrupulous, knowing and sensitive nature'. Lowinsky's paintings were executed with care, without any changes of mind or overtly expressive areas of brushwork. He was a meticulous worker, slowly and methodically painting his way across the picture surface. This results in very penetrating portrait studies, of which a notable example is 'Mrs James McKie'.

ALGERNON NEWTON
1880–1968

24 *The Surrey Canal, Camberwell* 1935

Oil on canvas 718 × 914 (28¼ × 36)
Purchased from the artist in 1940 for £210

Algernon Newton was a painter of urban scenes and landscapes. When he moved to London in 1919 from Berkshire, he spent much of his time at the National Gallery where he became interested in the work of Canaletto. Two aspects attracted him to the Venetian master: firstly Canaletto's technical mastery in the rendering of light and tonal relationships and secondly his favoured juxtaposition of cityscape and water. The latter led Newton to choose London's deserted waterways, particularly Regent's Canal running through Camden Town and Kentish Town, as subject material for his paintings.

'The Surrey Canal, Camberwell' is one of Newton's earliest paintings based on the Surrey Canal in South London. This area remained a favourite subject of Newton until about 1950.

The absence of any human figure, and the subtle combination of a lit street lamp with the large expanse of sky lit by the fading light of the sun lend a haunting quality to this painting.

HENRY LAMB
1883–1960

25 *Death of a Peasant* 1911

Oil on canvas 368 × 318 (14½ × 12½)
Purchased from the Leicester Galleries in 1944 for
£73–10s

Henry Lamb, a member of the Bloomsbury group, was
best known for his portraits and figure compositions.
He first visited France in 1907 when he went to study
at the Atelier La Palette, Paris. He returned there three
years later in the summer of 1910 with Augustus
John. During this stay he witnessed the death of a
peasant woman, Madame Favennec, who lived with
her family in Doelan. The woman was the mother of
ten children, the youngest of whom was two years old.

 She died of cancer of the throat, which caused her
emaciated state. Her husband Joseph leans over her,
his features distorted by grief. The picture was painted
on Lamb's return to London and met with critical
success when it was exhibited, being described later as
a 'modern Pietà'.

EDWARD LE BAS
1904–1966

26 *Interior* 1951

Oil on hardboard 933 × 1670 (36¾ × 65¾)
Purchased from the artist in 1951 for £210

In 1924, Le Bas went to study painting at the Royal
College of Art, having graduated from Cambridge in
architecture. As well as becoming an artist, he became
a patron of art and built up an impressive collection,
which was exhibited at the Royal Academy in 1963.

 'Interior' was painted in 1951 in the artist's studio
at 49 Glebe Place, Chelsea. Le Bas recalled in a letter to
the Tate Gallery of 27 December 1955 that he worked
'entirely from drawings – on unprimed absorbent
board.' The young girl sitting on the sofa is Kathleen
Baker, a model who sat for Le Bas in an earlier Chan-
trey painting 'The Tea Table' 1947–8, also in the col-
lection of the Tate Gallery.

RODRIGO MOYNIHAN
born 1910
27 *Portrait Group* 1951

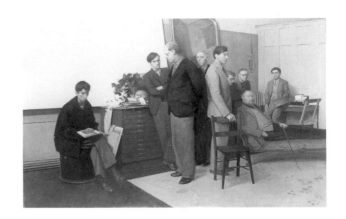

Oil on canvas 2134 × 3346 (84 × 131¾)
Purchased from the artist in 1952 for £1000

Painted for the Arts Council's '60 paintings for '51' exhibition to mark the Festival of Britain in 1951. The picture shows the teaching staff of the painting school of the Royal College of Art where Moynihan was Professor of Painting from 1948–57. The figures from left to right are John Minton, Colin Hayes, Carel Weight, Rodney Burn, Robert Buhler, Charles Mahoney, Kenneth Rowntree, Ruskin Spear and Rodrigo Moynihan himself, holding a palette in his left hand. The artist wrote (29 September 1959) 'I asked Buhler to paint me as it was difficult to get certain proportions – but I am certain it is mostly repainted by me'.

CAREL WEIGHT
born 1908
28 *The Rendezvous* 1953

Oil on canvas 864 × 1118 (34 × 44)
Purchased from the artist in 1953

Carel Weight has spent almost all his working life in London; as an artist he has created a unique brand of 'suburban surrealism', as a teacher he was an influential Professor of Painting at the Royal College of Art. 'The Rendezvous' was painted in February 1953 from drawings made in the grounds of Holland Park. Its atmospheric setting and the implicit ambiguity of the central action are characteristics of all Weight's work of which he has written the following in an exhibition catalogue introduction:

Even when I paint a landscape out of doors, and I say I'm not going to put any figures in; when I get back to the studio I always paint in figures! it would be too lonely without people. Dickens said that he invented characters and they ran away with him. The figures become so important it's difficult to interfere with them . . . I think that artists who just use their eyes to paint entirely visual pictures – although the imagination might creep in a bit – are very much hampered.

EDWARD BAWDEN
born 1903
29 *The Church Wall* 1954

Pen, ink and watercolour on paper 451 × 571
($17\frac{3}{4}$ × $22\frac{1}{2}$)
Purchased from the artist in 1955

The foundation of Edward Bawden's art lies in his
training as a designer at the Design School of the Royal
College of Art. His work has included posters, book
illustrations, wall-paper and tapestries designs, theatre
décor, mural painting and watercolours. The artist
wrote about this work in a letter (26 October 1956):

> Little Saling church [Essex] is mainly a
> 14th-century structure according to [Nicholas]
> Pevsner & the wall I chose to paint would seem to be
> the only external wall untouched by restoration,
> though obviously patched up from time to time. The
> drawing was done in late March, in watercolour on
> the basis of an ink drawing. It was a second attempt
> – the first drawing has now been fortunately
> destroyed.

DERRICK GREAVES
born 1927
30 *Domes of Venice** 1953–4

Oil on canvas 1841 × 1549 ($72\frac{1}{2}$ × 61)
Purchased from the artist in 1955

Greaves is a painter of figure subjects, still lifes and
landscape, both urban and rural. He trained first as a
signwriter, and then at the Royal College of Art where
he won a two year travelling scholarship (1952–4)
which he spent in Italy. During January and February
1953 he stayed in Venice and made drawings
and studies of the architecture there. In a letter
(2 December 1955) he stated:

> 'Domes of Venice' was painted from drawings and
> studies made from the top of the campanile in the
> Piazza San Marco . . . It was painted not in Venice
> but on my return [to England].

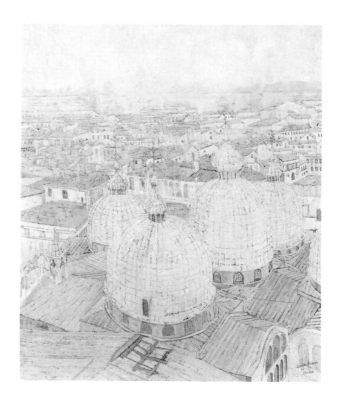

Greaves has chosen an unusual view of the Basilica of
St Mark in Venice. The building is one of the most
popular subjects for painters who normally depict its
western facade with the five domes above. Here
Greaves looks down on to the roof of the Basilica with
its domes and beyond to the roofs of the rest of the city.

HAROLD GILMAN
1876–1919

31 *Edwardian Interior** c.1907

Oil on canvas 533 × 540 (21 × 21¼)
Purchased from Hubert Wellington in 1956

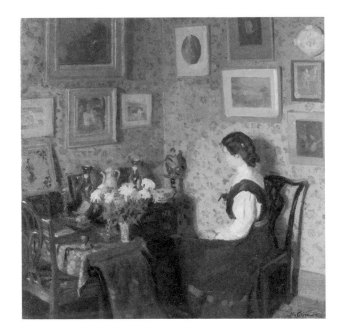

Gilman's career was terminated by his death while in his early 40s as a result of the 'flu epidemic of 1919. This charming view of his parents' home at Snargate, Kent, was painted when he was about 30, and is fascinating evidence for Gilman's changes of style during his life. He was first trained at the Slade School in London in the 1890s, which was then more noted for teaching drawing than painting. There Gilman responded to the vogue for subjects like Dutch seventeenth century interiors, and for rich tonal painting. He is now best known for the sharply coloured interiors, portraits and landscapes that he painted from 1912, and which are characteristic of the Camden Town School. The 'Edwardian Interior' is between these two styles. The figure seems almost to be ignored (it was possibly easy for him to take for granted his younger sister, who posed), and the picture stresses instead the contents of a domestic interior.

L.S. LOWRY
1887–1976

32 *Industrial Landscape** 1955

Oil on canvas 1143 × 1524 (45 × 60)
Purchased from the artist in 1956

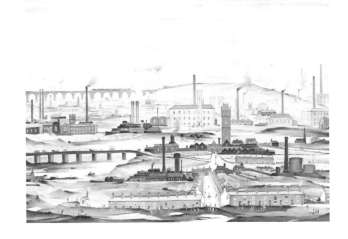

Born at Old Trafford, Lowry lived and worked throughout his life in Manchester and Salford. He was chiefly a painter of industrial landscapes. His paintings usually contain groups or crowds of figures, painted in a characteristic stick-like manner. In a letter to the Tate Gallery of 19 October 1956 he commented on 'Industrial Landscape':

> The picture is of no particular place. When I started it on the plain canvas I hadn't the slightest idea as to what sort of Industrial Scene would result. But by making a start, by putting say a Church or Chimney near the middle this picture seemed to come bit by bit.

HENRI GAUDIER-BRZESKA
1891–1915

33 *Horace Brodzky* 1913

Bronze 679 × 533 × 368 (26¾ × 21 × 14½)
Purchased from Horace Brodzky in 1935, and
presented to the Tate Gallery in 1957

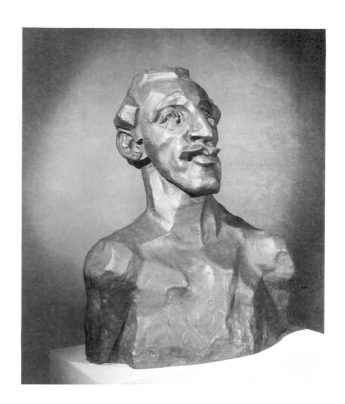

Henri Gaudier was a self taught sculptor and draughts-
man who learnt from studying art in museums and
galleries. In 1911 he left his native France to live and
work in London, accompanied by a Polish woman in
her 30s, Sophie Brzeska. They lived together and
added their surnames together. His career as a sculptor
only lasted three years from 1911 to 1914; he was
killed aged 24 fighting in the French army.

Horace Brodzky (1885–1969), the painter and art-
critic, first met Gaudier-Brzeska in January 1913 at his
studio in the Fulham Road, London. Brodzky, in his
biography of the sculptor, described the sittings for the
portrait:

> He was full of enthusiasm, and insisted upon my
> stripping to the waist, as he wanted to do the chest
> as well. My head was tilted back with the chin
> prominently forward. He worked in a most alarming
> fashion: jabbering all the time . . . he thumped the
> clay about, gouged out furrows, and all the time he
> was telling amusing stories. At the back of the bust
> he signed his name with a dedication in shorthand.
> In front he scratched a nude male and a girl's head.
> He did not explain the significance of these imaged
> drawings. And I am quite sure there was none.

JOHN MINTON
1917–1957

34 *Composition: The Death of James Dean** 1957

Oil on canvas 1219 × 1829 (48 × 72)
Purchased from the artist in 1957

John Minton was a painter and illustrator. According
to Rodrigo Moynihan, who was with Minton in Spain
in 1954, the subject of this picture was originally sug-
gested by a car accident they witnessed in Barcelona. It
also reflects Minton's interest in the death, in such an
accident, of James Dean, the Hollywood film actor, in
September 1955, at the age of twenty-four. Ruskin
Spear, who visited Minton's studio the day before his
death, said that Minton wanted everyone he knew to
see the picture and referred to it as 'James Dean and all
that'. Mr Spear suggested that Minton may even have
identified himself with James Dean, whose film rôles in
'East of Eden' released in 1954 and 'Rebel without a
Cause' released in 1955, and whose tragic death made
him a symbol of the anarchic younger generation
(conversation, 16 July 1958). Although the painting
appears to be unfinished the artist told Carel Weight
that he had said all he wanted in it.

SIR STANLEY SPENCER
1891–1959

35 *Dinner on the Hotel Lawn** 1956–7

Oil on canvas 949 × 1359 ($37\frac{3}{8}$ × $53\frac{1}{2}$)
Purchased from the artist in 1957

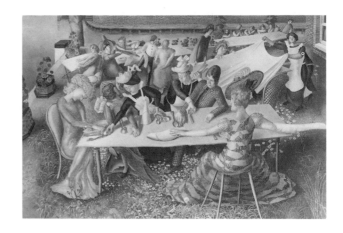

Stanley Spencer lived much of his life in his home village of Cookham in Berkshire and drew upon his home surroundings for his imaginative and religious subject paintings. 'Dinner on the Hotel Lawn' is the fourth, and last, of a series of pictures known as the 'Cookham Regatta' series. Begun in 1952 it was intended as a sequel to Spencer's decorations for the Burghclere Memorial Chapel (1926–32) which were based on his experiences in Macedonia in the First World War. This time the action was set in Cookham and Spencer used his youthful memories of the Regatta there; the central picture was to show Christ preaching from the Horse Ferry barge, and in this work the Regatta dinner takes place on the lawn of the Ferry Hotel. In a letter of September 3rd 1957 Spencer spoke of wanting to create:

> an absolute galaxey [*sic*] of glamourous happenings on the Hotel lawn

and continues by describing the long tables as being:

> a little reminiscent of the long punts. In all of them I seem to have forgotten about the food . . . and I was annoyed to notice that I had made the servants putting the knives on the wrong side: and they are doing it so nicely!

VICTOR PASMORE
born 1908

36 *The Quiet River: The Thames at Chiswick**
1943–4

Oil on canvas 762 × 1016 (30 × 40)
Bought from Lady Herbert in 1958

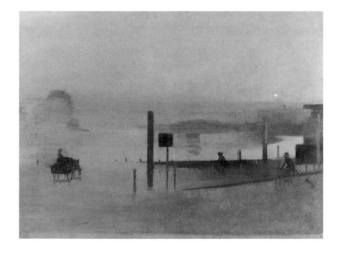

One of four paintings on the same subject painted between 1943–7, 'The Quiet River' shows the view across the Thames with Eyot Island in the background bathed in a dusk light. It was painted from Pasmore's house at 16 Hammersmith Terrace, where he and his wife lived from early 1943 to 1947. The impressionistic handling and quiet tonality reflect Pasmore's work of the 1930s and his earlier admiration for the art of Turner and Whistler, whilst the independence of certain shapes within the composition (fences, poles and notice board) herald a new abstract approach. Pasmore regards this picture as an important stage in his artistic development, and by 1948 with paintings like 'The Quiet River' as experience, he made a move into painting abstract pictures, which he still produces to this day.

[70]

Sir William MacTaggart
1903–1981
37 *Duet* 1958

Oil on two pieces of millboard laid on hardboard
$610 \times 1010 \ (24 \times 39\frac{3}{4})$
Purchased from the artist in 1960

Sir William MacTaggart was a painter of landscapes and still lifes, the grandson of another Scottish painter also called William MacTaggart. The painting consists of two flower studies on two separate pieces of millboard joined together to make a single work of art. The artist wrote (8 September 1960):

> The theme of my 'Duet' is one which has interested me very much recently. I like to relate close-up objects such as fruit and flowers, to a landscape background, and to do this I generally use the view from my studio window as a starting point. My studio looks out on to a fine old Edinburgh square with trees and houses beyond, and a church tower. I use the symbols of this material very freely to compose a great many of my paintings.
> 'Duet' had another theme which interested me at the time and that was to juxtapose a warm panel with a cool one, the warm panel having notes of cool colour and the cooler panel echoing and repeating some of the warm colour from its neighbour.

Tristram Hillier
1905–1983
38 *Alcañiz** 1961

Oil on canvas $698 \times 800 \ (27\frac{1}{2} \times 31\frac{1}{2})$
Purchased from the artist in 1962

Hillier first visited Spain in 1935; he returned there and to Portugal regularly after 1946 and painted many architectural views and landscapes of the country. Hillier's paintings are notable for their clarity and precision. They offer views of stillness and silence, all lit by a cloudless sky which initiates deep shadows. A commentator has, however, noted that Hillier's stillness is 'not inertia but tension'. In a letter (19 July 1961) Hillier wrote:

> Alcañiz is a small town in the province of Teruel [Spain] about sixty-five miles south of Zaragoza. I made some drawings and notes while I was staying there [in 1961] of the principal square, Plaza de España, and painted the picture – as is my usual practice – in my studio [in Somerset]. The medieval buildings were once a royal palace but are now the Town Hall.

WILLIAM ROBERTS
1895–1980

39 *The Vorticists at the Restaurant de la Tour Eiffel: Spring, 1915* 1961–2*

Oil on canvas 1829 × 2134 (72 × 84)
Purchased from the artist in 1962

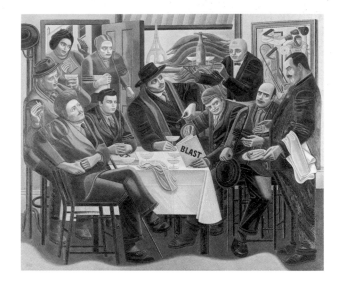

After training at the Slade School of Art, Roberts worked briefly with Roger Fry at the Omega Workshops before joining Wyndham Lewis at the Rebel Art Centre. He exhibited as a member of the Vorticist Group (1915) and served as an Official War Artist in the First World War. After the war, Roberts devoted the rest of his long career to developing a highly personal style of portraiture and figure compositions derived from his early, cubist inspired works.

This imaginative reconstruction of the Vorticist artists at the Restaurant de la Tour Eiffel in Percy Street features from left to right seated: Cuthbert Hamilton, Ezra Pound, William Roberts, Wyndham Lewis, Frederick Etchells and Edward Wadsworth; standing in the doorway are Jessica Dismorr and Helen Saunders, the waiter Joe and Rudolph Stulik, proprietor of the restaurant from 1908–1937, are on the right. Etchells is holding Volume I of the Vorticist publication *Blast*.

In the late 1950s, Roberts recalled these evenings at the restaurant in *The Listener* (21 March 1957):

> In my memory la cuisine française and Vorticism are indissolubly linked . . . M. Rudolph Stulik of the Tour Eiffel should rank in the records of Vorticism as [an] honorary member of the 'Group'.

OLWYN BOWEY
born 1936

40 *Portrait Sketch of L.S. Lowry*, ARA 1963–4

Oil on canvas 914 × 711 (36 × 28)
Purchased from the artist in 1964

The artist wrote that she first met Lowry in November 1963 (30 August 1964):

> He was such an endearing character with such a humorous face that I couldn't resist asking him if he'd sit for a portrait. He really was most kind about this, because his visits to London are somewhat few and far between, and he sat for one Sunday afternoon when I painted as rapidly as I could and took the picture nearly to a conclusion. He was very patient, and mostly talked about our common background of the North of England. I don't think he could see why I had left such a marvellous place to come and live in London. His sense of humour is great, and somehow or other he kept me entertained all the time I painted. The picture is only two sittings but I thought it couldn't be anything but a sketch, even though I wouldn't want now to take it any further – as I feel it is the result of two inspired visits. Mr Lowry himself teased me into putting in the red background – he dared me to brighten it up.

FRANK DOBSON
1888–1963
41 *Female Nude* c.1927–8

Bronze 400 × 102 × 76 (15¾ × 4 × 3)
Purchased from the artist's widow in 1964

Dobson was trained as a painter. He turned to sculpture tentatively in 1913 and fully in 1919. His favourite subject for sculpture was the female nude, either standing or reclining and he fashioned her carved from stone and modelled from clay or terracotta. Dobson visited France in 1926 where he admired the recent work of Picasso and Matisse, echoes of which can be seen in 'Female Nude'. The pose, however, with the left hand lifted to the left shoulder, and the right arm placed over the head follows closely the upper part of a figure of a nude woman by the Russian sculptor Archipenko, made in Paris in 1910. Dobson's sculptures of women personify moods or emotional states, which can be defined by words like harmony, serenity, rhythm and repose.

IVON HITCHENS
1893–1979
42 *Coronation** 1937

Oil on canvas 902 × 1219 (35½ × 48)
Purchased from the artist in 1964

While the majority of Hitchens' paintings were inspired by the verdant foliage of the English countryside, 'Coronation' is one of a number of abstract or near-abstract works which the artist painted in the mid-1930s. It was painted shortly after the Coronation of King George VI in May 1937 and was partly influenced by Hitchen's ideas about the musical quality of art.

Hitchens married Mary Coates, a pianist, in 1935 and this helped him to consolidate his views on the links between painting and music, which he felt shared a common language of harmony, rhythm, tempo, pulse and structure. He said of his work 'My paintings are painted to be listened to'.

In a letter (5 April 1965) Hitchens wrote:

The title ['Coronation'] was suitable because of its colours and occasioned perhaps by the events 'in the air' at the time – and the two 'forms' in the blue panel. It would be unwise to seek for any more direct symbolism.

DUNCAN GRANT
1885–1978

43 *The Tub** *c.*1913

Watercolour and wax on paper laid on canvas
762 × 559 (30 × 22)
Purchased from Wildenstein & Co. Gallery in 1965

A nude woman stands knee deep in an oval bath-tub
and pours water over her head. A single stream of
water cascades down in a line in front of her body. Her
raised arms are reflected in a round mirror positioned
behind her. The crude drawing of her body owes much
to Grant's new found admiration for African sculpture,
which was then very popular with Parisian artists
such as Picasso and Matisse, who were at the time
friends of Grant.

Grant worked alongside his Bloomsbury group col-
leagues Roger Fry and Vanessa Bell at the Omega
Workshops in 1913, where he produced designs for
textiles, murals, pottery and painted furniture. The
geometric patterns seen on the curtains to the side and
behind the bather in 'The Tub' are very close to a rug
design which Grant produced at the Omega Work-
shops in 1913.

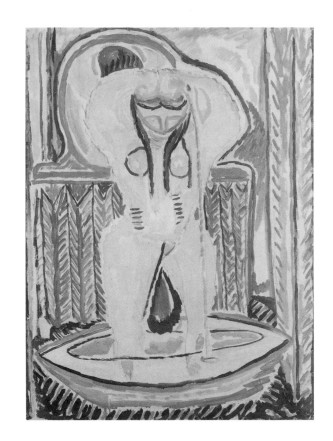

ANNE REDPATH
1895–1965

44 *The Poppy Field* 1963

Oil on canvas 762 × 762 (30 × 30)
Purchased from the artist's executors in 1965

Redpath was born in Scotland, the daughter of a
designer of tweed cloth. In 1920 she married and went
to live in France for the next fourteen years, combining
bringing up a family with the painting of pictures.
After her return to her native Scotland she frequently
visited the Mediterranean coastline, and scenes from
the area constitute one of her main subjects. Her paint-
ings are good examples of the Scottish school with
their love of bright colours, and a loose expressive
manner of laying the paint on to the canvas.

In a letter (5 December 1965) the artist's son, David
Michie, also a painter, wrote:

'The Poppy Field' was painted in 1963 following a
visit to the south of France made in the late spring of
that year. My mother stayed at Vence and she made
little trips around the town and made notes and
colour sketches of things that interested her. This
was the normal way she worked. 'The Poppy Field'
was the result of one of these notes.

ELIZABETH BLACKADDER
born 1931
45 *Still Life with Pomegranates** 1963

Oil on canvas 864 × 1118 (34 × 44)
Purchased from the artist in 1966

Blackadder was born in Scotland and studied art in Edinburgh. A travelling scholarship took her to Italy in 1955–6 and she has also worked in France and Portugal. She collects objects and textiles from her travels which then appear in her still lifes. A typical collection of still life objects set out on a large table top in her studio would include patterned fabrics, fruit and a jug or pot, just as they are gathered together for this painting. She likes to paint in a loose expressive way and her paintings have a luminous quality, often with dark toned shapes seen in silhouette set against a smudged lighter area. The painter Carel Weight has written of her work 'The world she creates is about light falling upon objects, which sometimes seem on the point of disintegration and becoming abstract'.

SHEILA FELL
1931–1979
46 *Haystack in a Field* 1967

Oil on canvas 711 × 914 (28 × 36)
Purchased from the artist in 1968

This work was almost certainly painted around Sheila Fell's home in Aspatria, Cumberland. Although Fell spent most of her later life in London, she continued to make frequent visits to her family in Cumberland and took her subjects from the landscape there. 'Haystack in a Field' was possibly painted in her studio from sketches made in the field. The artist wrote:

> The closeness of my relationship with Cumberland enables me to use it as a cross section of life. All the landscape is lived in, modulated, worked on and used by man. I do not want to be thought of purely as a landscape painter. I hope that the nearby community is always implicit in my landscapes.

EDWARD MIDDLEDITCH
1923–1987

47 *Sheffield Weir II* 1954

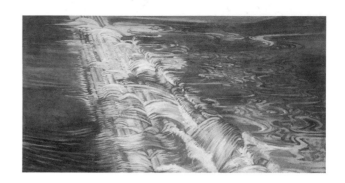

Oil on board 914 × 1505 (36 × 59¼)
Purchased from Marlborough Fine Art in 1968

Middleditch served in the Second World War before
studying in the Painting Department of the Royal Col-
lege of Art. He and fellow students, John Bratby, Der-
rick Greaves and Jack Smith, formed the nucleus of the
group of Realist painters known as 'The Kitchen Sink
School'.

Throughout his career Middleditch was fascinated
by natural forms, e.g. plants and the flow of water, and
the two 'Sheffield Weir' paintings formed part of a
series. In 'Sheffield Weir I' 1954 (Manchester City Art
Galleries), the terraced streets of Sheffield rise like a
mountain above the weir, while in 'Sheffield Weir II',
the artist has concentrated on the water itself.

VANESSA BELL
1879–1961

48 *Helen Dudley* c.1915

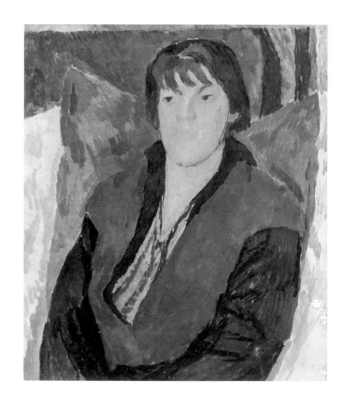

Oil on canvas 724 × 610 (28½ × 24)
Purchased from the artist's daughter, Mrs Angelica
Garnett, in 1969

Vanessa Bell was the elder sister of the novelist Virgi-
nia Woolf, and these two women were responsible in
part for the formation of the so-called 'Bloomsbury
Group' of artists, writers and intellectuals.

Vanessa Bell and Duncan Grant were the painter
members of this group, and for a time around 1914
they experimented with an abstract style of painting
which concentrated on strong colours and elementary
forms. At this time Vanessa Bell was also making dec-
orative art – painted screens, pottery and a mosaic –
for Roger Fry's design scheme, the Omega Workshops,
and there is a sense of decorative drawing in the design
of this portrait.

Vanessa Bell most frequently painted still lifes and
portraits of her friends. Helen Dudley was the daughter
of a Chicago gynaecologist, who met the philosopher
Bertrand Russell in America. Russell recalled how,
having earlier studied at Oxford under Gilbert Murray,
Helen Dudley returned to England in 1914. Vanessa
Bell painted this portrait at 'Durbins', Roger Fry's
home near Guildford, before Helen Dudley's friendship
with Russell broke up.

PETER GREENHAM
born 1909
49 *Father d'Arcy* 1975

Oil on canvas 762 × 521 (30 × 20½)
Purchased from the artist in 1976

Peter Greenham has painted portraits of his family and friends, as well as commissioned portraits, throughout his career.

Lady Brinsley Ford suggested to the artist that he should paint a portrait of Father Martin d'Arcy (1888–1976) the writer, lecturer and broadcaster, who was Master of Campion Hall, Oxford from 1933 until 1945. Father d'Arcy was painted and drawn by several other artists including Augustus John and Wyndham Lewis.

The portrait was painted in four or five sittings, each of one and a half to two hours, between about 10.30 am to 12.30 pm in May and June 1975 in Father d'Arcy's small London bed-sitter. Since he was rather frail, Father d'Arcy spent most of his time indoors. Greenham made a few drawings of his head and hands, which at one time were clasped together. As the sitter moved his hands they were omitted from the finished oil.

ANTHONY GREEN
born 1939
50 *L'Heure du Thé, Argenton-sur-Creuse* 1980

Oil on hardboard 1994 × 2210 (78½ × 87)
Purchased from the artist in 1980

This is based on the artist's memories of staying with his mother's sister Yvonne and her husband at Argenton-sur-Creuse in France. There he often visited a married couple, friends of his aunt. On occasions he would take tea with the wife whom Green describes as being 'promiscuous, beautiful, charming and very erotic'; they would drink lemon tea and eat pastries known as *religieuses*. On the left Yvonne is seen from the back talking to the husband. Through the glass of the conservatory can be seen the statue of the Golden Virgin on the pinnacle of the chapel, which dominates the town. On the right the teenage Green drinks tea.

The centre part of the picture shows the lady of the house naked. This, says Green, is about adolescent sexuality and 'what was in my head'. Meeting her he says 'was the first time I was aware of a woman "as a woman"'. When he took tea with her she was clothed and sitting in a chair, and not in fact lying naked on the dining room table. At no time did Green see her naked.

The format of the painting is irregular. Green has been painting pictures of irregular shapes since 1964 and he sees 'no reason why paintings should be of regular format'.

MAGGI HAMBLING

born 1945

51 *Max Wall and his Image* 1981

Oil on canvas 1676 × 1219 (66 × 48)
Purchased from the artist in 1983

When Maggi Hambling saw Max Wall, the well-
known actor and music-hall entertainer in his one-
man show 'Aspects of Max Wall' at the Garrick
Theatre in 1981, she was moved by his performance:

> He has the true face of the sad clown, and possesses
> that power I can only call magical to make one
> laugh and cry at the same moment . . . I believe that
> the art of the clown in demonstrating to us the
> absurdities of life is a very necessary part of life.

The setting for this portrait is Hambling's studio and
the arrangement of black cloth, stools, drawing boards
and crates was set up by the artist. The shadow behind
Max Wall's right shoulder refers to his celebrated
character, Professor Wallofski, the part with which
he is most frequently associated. Wall is wearing the
costume he had worn during the first half of his one
man show. The two flying eggs refer to an egg which
Wall used to demonstrate a conjuring trick during a
sitting and an egg he gave to the artist as a present.

LEONARD McCOMB

born 1930

52 *Portrait of Zarrin Kashi Overlooking
Whitechapel High Street* 1981

Watercolour on paper laid on cotton duck
1840 × 1885 (72⅜ × 74¼)
Purchased from the artist in 1983

Zarrin Kashi is an Iranian who at the time of this
picture was working as a professional model. The set-
ting is a room in the Sir John Cass Faculty of Art, part
of the City of London Polytechnic. The cityscape has
been freely composed from buildings in the East End of
London which were visible from the window.

In a letter (30 May 1986) the artist wrote:

> The window was opened as a device to connect
> Zarrin and the internal room with the
> unsympathetic city landscape outside. Zarrin
> standing with natural dignity, a creature of the sun,
> against the mish-mash of Victorian and
> contemporary tower blocks.

The curved lines around the model's body are used
as a contrast to the horizontals and verticals which

predominate in the cityscape. The inscription along
the bottom of the work reads 'My name is Zarrin, I am
my father's daughter and my father loves me.'

LAETITIA YHAP
born 1941
53 *Michael Balling up Old Net* 1984

Oil on plywood and acrylic on integral softwood
surround 1205 × 1496 (47½ × 58⅞)
Purchased from the artist in 1984

In 1968 Laetitia Yhap left London and went to live in
Hastings. 'Michael Balling up Old Net' was painted in
1984 in the artist's studio at 12, The Croft, Hastings.
The setting is a local beach known as 'The Stade'
with the wall of the lifeboat house on the right. The
fishermen are at work repairing the nets, a task which
takes place during the summer months, when there is
no fishing. Michael Rycroft, the figure who is rolling up
the net, is a full time fisherman who lives with the
artist.

In a letter (25 February 1988) Yhap commented:

> For me the business of net making seems akin to the
> work of the spider. It is a web to catch prey and its
> size in relation to the creature who makes it is
> immense.

Yhap usually makes her own frames although for this
frame a local boatbuilder steamed the pieces of wood
together. The unusual shaped frame is characteristic of
Yhap's work. She considers it an integral part of the
painting as it is constructed before the painting and is
crucial to the composition of the image.

ADRIAN BERG
born 1929
54 *Gloucester Gate, Regent's Park, May 1982**
 1982

Oil on canvas 1775 × 1774 (69⅞ × 69⅞)
Purchased from the artist in 1985

Berg lived and worked on the top floor of 8 Gloucester
Gate, Regent's Park, London from 1961 to 1985,
where the canvas was painted. His flat, which was part
of a Nash terrace on the outer circle of Regent's Park,
had a balcony and access to the roof. This gave him
extensive views across the lawns and trees of Regent's
Park from about tree-top level. Because Berg was able,
from his high level studio, to look in both westerly and
northern directions, he painted a series of pictures
which fuse different views together.

In a letter (19 June 1988) Berg wrote about 'Glou-
cester Gate, Regent's Park':

> Everything in the painting can be seen from my
> studio window. Naturally I can see through an arc
> of 180°. In choosing to fill a square canvas with this
> view I have, as it were, doubled the number of
> degrees, and joined what I see on the extreme left to
> what I see on the extreme right.

While painting 'Gloucester Gate, Regent's Park' Berg
turned the canvas around and although he preferred
the orientation reproduced here it can be viewed from
four ways round.

NORMAN BLAMEY
born 1914

55 *Decoy Duck and Self Portrait* 1984–5

Oil on cotton sheet laid on board
1220 × 1220 (48 × 48)
Purchased from the artist in 1985

This was painted in the artist's studio in north-west London over a period of about three months in the winter of 1984–5. The objects depicted are ones which have a valued place in Blamey's studio and home. The decoy duck was bought by the artist's wife in an antique shop in Islington in the late 1970s and the wooden column was bought by the artist and his wife from an antique shop in north-west London c.1960. When purchased it was covered with layers of old dark brown paint and had a large rectangular top. It has since been stripped of its paint to reveal the wood underneath and the artist had a light coloured circular pine top made to replace the earlier top. The expanse of wood panelling which fills the middle ground of the picture is the back of an 18th century settle, which the artist and his wife bought from an antique shop in Camden Town, London in the early 1960s. The mirrors, which are hung opposite each other on the studio walls and thus reflect each other, were bought at the same time from an antique shop in Camden Town, London in the early 1970s.

Blamey has often used the device of setting a small mirror reflection of himself in his paintings. He stresses that this is not so much to present himself in the guise of a self-portrait, but rather as a reminder that he is the creator of what the viewer sees.

Sir Francis Chantrey: Further Reading

J.S. Memes	*Memoirs of Antonio Canova, with a critical analysis of his works and an historical view of Modern Sculpture,* Edinburgh 1825
George Jones	*Sir Francis Chantrey, R.A.: Recollections of His Life, Practice and Opinions,* London 1849
J. Holland	*Memorials of Sir Francis Chantrey,* London and Sheffield 1851
G.D. Leslie & F.A. Eaton	'The Royal Academy in the Present Century', *The Art Journal,* 1899, pp.115–118
D.S. MacColl	*The Administration of the Chantrey Bequest,* London 1904
Alfred Munnings	*The Finish,* Vol. 3 of his Autobiography, London 1952, pp.116–128
G.D. Leslie	*The Inner Life of the Royal Academy,* London 1914
A.J. Finberg	*The Life of J.M.W. Turner, R.A.,* Oxford 1961
Douglas Hall	'The Tabley House Papers', *Walpole Society* vol.38, 1960–1962, pp.59–122
Alex Potts	*Francis Chantrey, 1781–1841; Sculptor of the Great,* National Portrait Gallery, London; Mappin Art Gallery, Sheffield 1981 (Exhibition catalogue)